Kurelek Country
THE ART OF WILLIAM KURELEK

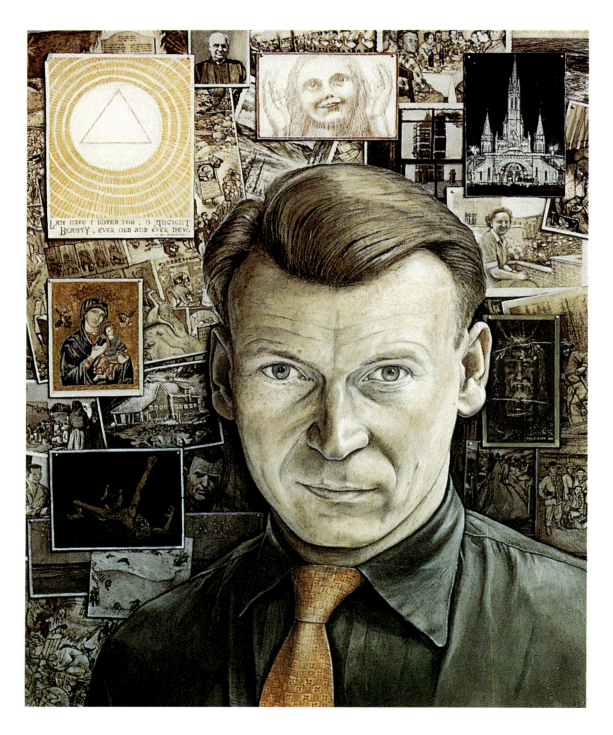

SELF-PORTRAIT 1957
Oil
Dimensions: 24 x 18

Kurelek Country

THE ART OF WILLIAM KURELEK

Preface by Avrom Isaacs

Essay by Ramsay Cook

KEY PORTER BOOKS

Canadian Cataloguing in Publication Data

Kurelek, William, 1927-1977
 Kurelek country

ISBN 1-55263-085-7

1. Kurelek, William, 1927-1977. 2. Canada in art. I Isaacs, Avrom, 1926- II. Title.

ND249.K87A4 1999 759.11 C99-931505-6

The Canada Council | Le Conseil des Arts
for the Arts | du Canada
SINCE 1957 | DEPUIS 1957

The publisher gratefully acknowledges the support of the Canada Council for the Arts and the Ontario Arts Council for its publishing program.

Canada

We acknowledge the financial support of the Government of Canada through the Book Publishing Industry Development Program (BPIDP) for our publishing activities.

Key Porter Books Limited
70 The Esplanade
Toronto, Ontario
Canada M5E 1R2

www.keyporter.com

All paintings courtesy of The Estate of William Kurelek and the Isaacs Gallery, Toronto.

"Canada, Quebec and the Uses of Nationalism" by Ramsay Cook, used by permission of McClelland & Stewart, Inc. The Canadian Publishers.

Design: Peter Maher

Typeset in Goudy Old Style

Electronic formatting: Jean Lightfoot Peters

Printed and bound in Spain by Bookprint S.L., Barcelona

99 00 01 02 03 6 5 4 3 2 1

Contents

Preface

IN 1959, A FEW YEARS AFTER I OPENED THE ISAACS GALLERY, I was visited by a young, very quiet individual whose name was William Kurelek. At that time I had a framing shop in the back which was the main means of support for the Gallery. Bill had come to apply for a job as a picture framer. He had just returned from England where he had apprenticed in a master framer's shop. He brought along three or four of his paintings in order to impress me with his serious attitude.

I recall that I was so taken with the paintings that I immediately offered him an exhibition. At the same time I gave him a job in my shop making sample frame corners. Bill was a master gilder. I still have one of his gold and silver leaf frames, which is really in itself a work of art.

His first exhibition in March 1960 was an immediate and sensational success.

He later told me that the reaction so affected him that it seemed to trigger an effect similar to the opening up of the floodgates in a dam. Paintings began to pour out of him. There was no letup almost until the day he died. His energy and drive were a constant source of amazement to me. In the very brief period of twenty years after his return to Canada, he produced more than two thousand works, mostly paintings.

Bill is popularly known as a painter of Western Prairie scenes but, in fact, the scope of his work is enormous. His vast body of work spans a wide range of subject matter, covering political, social, ethnic, religious and historic themes. Not until a large major exhibition of his work is organized will the public be able to appreciate this fact.

Bill was a possessed individual—possessed with a sense of urgency of how much he had to say, possessed with a sense of "doomsday" and how we must face up to this fate, both spiritually and in practical terms. He built a bomb-shelter in the basement of his house and stocked it with provisions. He once told me that he allowed himself only four hours a night's sleep as he had so much to do. I remember him saying to me, "My peace will come after my death." This was an artist who had come through very difficult times, both personally and financially. He had recently converted to Catholicism which was a great comfort to him. He felt that life was a very brief episode. He held ardent religious beliefs and gave a great deal of time to the practical application of his convictions. On his return to Canada, he had thought of opening a gallery which would be devoted to religious paintings.

Bill was a shy person who felt that he had an obligation to take every opportunity to carry his message forward. I suspect that this drive cost him a great deal emotionally. I recall that at one of his openings, he asked me if he could address the viewers. I stood and watched him wringing his handkerchief behind his back as he spoke.

Kurelek is the most published visual artist in Canada. Twenty books related to his art and his life have been published and over a million copies of them have been sold in many countries. Two of his books received awards from the *New York Times*.

Bill felt intensely about communicating with the public. Although he was the most literal artist that I represented, each painting in many of his exhibitions would have an explanatory text beside it. In addition, he usually wrote an essay as a foreword to the show. He wrote simply, but well. He wanted to make doubly sure that his intent was understood.

During the 60s and 70s, he tended to be overlooked by the public galleries because abstract expressionism was the vogue. But the public took him up immediately; they recognized him.

His art is essentially minimal (the Prairie landscapes often seem to contain little more than a foreground, sky, telephone poles and a wire fence). It is deceptively simple. When you live with his work, you find that it keeps bearing down on you. The works all seem to have a deeply spiritual sense to them.

He painted for everyman. Much of his work has a sense of history. He described the West of the 30s and 40s with great accuracy. He is a great moralist.

Bill was of Ukrainian/Canadian descent. Toward the end of his life, his heritage became more pronounced and he wanted to create a major mural in Ottawa on the Ukrainian/Canadian theme. He was already ill when he visited his father's village in the Ukraine to research material for his work. He returned after three weeks with the incredible number of 100 drawings and six paintings. Soon after his return he entered the hospital. Up to the day of his death, he was trying to do the finishing touches to his drawings. He was a superb draftsman. The drawings are a joy.

Avrom Isaacs
Toronto, February 10, 1991

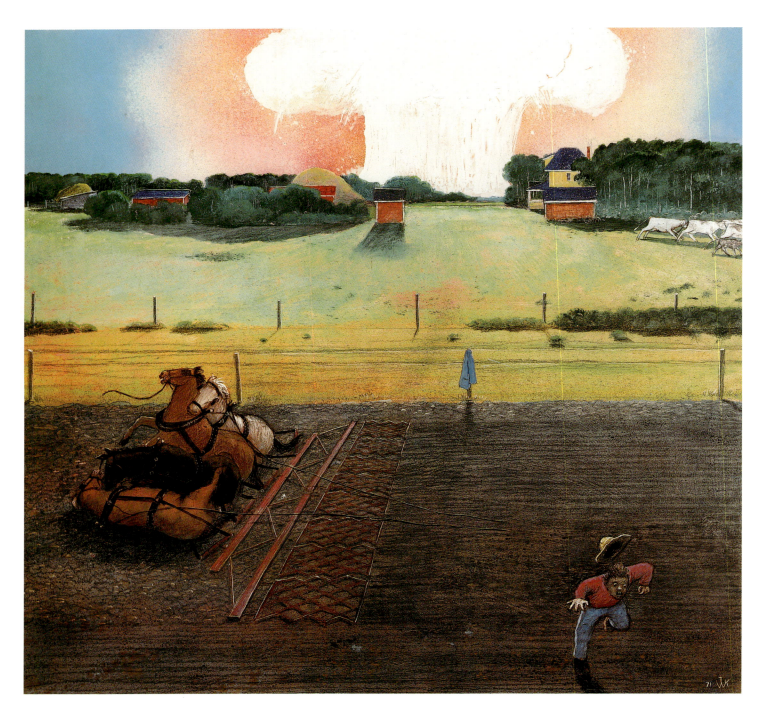

NOT GOING BACK TO PICK UP A CLOAK 1971
Kurelek's Vision of Canada Series
Mixed Media
Dimensions: 19 x 19 inches
Collection: The Isaacs Gallery

R A M S A Y C O O K

William Kurelek: A Prairie Boy's Visions

He approached everything with a mind unclouded by current opinions.
T. S. Eliot, "William Blake"

WILLIAM KURELEK WAS SURELY THE MOST AUTOBIOGRAPHICAL of Canadian painters. He painted pictures of childhood memories, the history of his people and the moral dilemmas of contemporary life. He set out in often startling ways his own psychological torments and the religious answers he found for them. He was a storyteller who felt compelled to tell his stories in paint. Nor did self-revelation end with the brilliantly executed canvasses. Kurelek feared that he might be misunderstood. His paintings often were accompanied by detailed explanations written in a very personal fashion, direct and concrete. Nor did the explanation stop on the gallery walls. There were films, particularly *The Maze*, and above all the sometimes excruciatingly frank autobiography, *Someone with Me*. Finally, there were introductions to shows, manifestoes, diaries, letters and jottings. What is left to be said about this exceptionally talented, wonderfully prolific artist? His paintings, books and reproductions have probably been viewed by more people than any other Canadian artist's, for he was, as has often been noted, "a people's painter."[1] What is there to be said that Kurelek, either in paint or print, has not already said for himself?

Perhaps the answer lies in the deceptively literal quality of his paintings. That literal quality, and perhaps even the careful explanations, disguised the complexity of the visions that lay behind them. The artist recognized his own problem when he wrote in 1973 that "My image has perhaps become set as a portrayer of farm life or else I represent a missionary in paint."[2] Since so much of the art of the modern age is abstract and non-representational, Kurelek was admired by those who wanted to be able to understand, even to identify with, what they saw. And then when Kurelek painted pictures that could not be mistaken for photographs, since they contained Christ-figures, demons and other extraordinary creatures, he was often rejected. Even a generally sensitive and sympathetic critic remarked in 1963 that "where Kurelek fails miserably is when he attempts to paint subjects which he knows about only from dogma and not from experience, where in fact he is a theological tourist in never, never land."[3] Such responses displayed a fundamental misunderstanding: Kurelek was an artist, not a photographer. His farm paintings and his religious paintings were the product of the same imagination. He saw them both for, as an eminent art historian has insisted, "painting is an activity and the artist will therefore tend to see what he paints rather than to paint what he sees."[4] The scenes from "The Passion of Christ According to St. Matthew" were as "real," if that is the correct word, as those

that make up *A Prairie Boy's Winter*. Each expressed one of Kurelek's visions. There were several visions, or themes, in Kurelek's work, though they are all part of a single way of looking at the world.

II

WILLIAM KURELEK'S LIFE EXPERIENCE SHAPED HIS ARTISTIC vision in a very direct fashion. "Portrait of the Artist as a Young Man," painted in 1950 when Kurelek was much under the influence of James Joyce, portrays the artist as a romantic hero. "I was going to be Stephen Daedalus," he later remembered. "I would wear my own phoney costume, not the establishment's phoney costume."[5] Yet the background contains those scenes from early life that were to recur, in varying ways, in his later painting. It is hardly necessary, since the release of the film *The Maze* in 1971 and the publication of *Someone with Me* in 1973, to repeat in detail the story of Kurelek's life or to insist upon the complexity of the man.

Born in Alberta of Ukrainian-Canadian parents in 1927, he grew up on a farm in Alberta and, more important for him, near Stonewall, Manitoba, during the Depression. He attended high school in Winnipeg and later graduated from the University of Manitoba. Then he tried art school in Toronto and, later, Mexico. Neither school satisfied him; as an artist he was essentially self-taught and always believed that old-fashioned apprenticeship was the only real way to learn painting skills. His growing up was painful: conflict with his family, with his surroundings, whether on the farm or at school, and above all with himself. Academically he did well, but he was extremely thin-skinned and found personal relations almost impossible. Above all there was conflict with his father who, perhaps not so surprisingly, found it difficult to understand a young man who wanted to be an artist. One thing Kurelek learned from his father was a prodigious capacity for work, and he used it in a wide range of employment: farming, logging, carpentry, brick making, car washing, picture framing, painting. (On a painting trip in 1967 he wrote: "My rigid schedule had me working at fever pitch sometimes. All of the visitors who heard of my work or came to see it couldn't believe I'd done so much detailed work. I gave the credit to my father for teaching me to work hard and whenever I could to God for giving me the talent."[6]) His struggle to find himself, to become a painter, led through the depths of a personal hell, depicted in such paintings as "I Spit on Life," "The Maze" and "Behold Man without God" (1955), the latter painted before, and named only after, his conversion to Roman Catholicism. The period spent in psychiatric care in Great Britain led to the resolution of his personal crisis, and he emerged a totally committed Christian and a man resolute in his vocation as an artist. Convinced that his recovery was a miracle of God, not science, he rejected suggestions that his account of these years would have been improved by blue-pencilling the

lengthy theological discussions. That, he insisted. would have meant "cutting the heart out of the body."[7] Kurelek had now found his mission: it was to use his talents, as he believed God intended that he should, in supporting the cause of Christian belief and action. "What I am sure of," he wrote at the end of his autobiography, "is that I am not really alone anymore in the rest of my journey through this tragic, yet wonderful world. There is Someone with me. And He has asked me to get up because there is work to be done."[8] "Self-Portrait," painted in 1957, is no longer the rebellious Stephen Daedalus looking inside himself. The artist is now looking outward against the background of a past to which many religious symbols have been added.

In 1959 he returned to Canada and to Toronto, a city where, in a style and a mood now radically altered, he had once painted "Depression in Toronto" (1949). He found work as a picture framer, a skill he had learned in England, at The Isaacs Gallery. That was the beginning of a somewhat tempestuous relationship, this time with the man who, the artist later wrote, "first recognized the merit of my work and took the risk of exhibiting it."[9] Shortly afterwards, through his work with Catholic Action, he met and then married Jean Andrews. The painting, "Mendelssohn in the Canadian Winter" (1967), was so named because of a violin concerto written by Mendelssohn "to describe a happy time in his life at the beginning of his marriage and the starting of his family."[10]

The great themes that were to dominate his artistic life had already begun to emerge, but now the work poured forth and the themes became firmly fixed. Four of these themes seem most important and recurrent, though the choice is obviously somewhat subjective.

III

THE FIRST THEME IS CHILDHOOD. CANADIANS BORN ON THE prairies are especially fortunate in at least one respect. Their childhood has been immortalized by two great artists: W. O. Mitchell, the author of *Who Has Seen the Wind*, and William Kurelek, whose work, including *A Prairie Boy's Winter* and *A Prairie Boy's Summer*, is filled with scenes of childhood. One painting, "Farm Children's Games in Western Canada" (1952), depicts many memories of boyhood, memories that were for the most part happy ones, even though Kurelek's own childhood experiences were much more mixed. It was these memories that fuelled his imagination and won him his first public successes. Another painting, "Memories of Manitoba Boyhood" (1960), suggests the way in which the artist constantly reworked this theme that was so much a part of the story he had to tell.

Kurelek's vision of childhood is powerful and alive, whether in the joy of games, the hard work of the farm or the struggle against the elements. Perhaps its success comes from the nostalgia it creates. But there is more to it than that. A prairie poet and critic, Eli Mandel, has drawn attention to the frequent reappearance of the child figure in the prairie

landscape in western Canadian writing. He explains it by observing that from the adult perspective "the child's vision is the vision of innocence, of a lost Eden.... [It is] the vision of home ... the overpowering feeling of nostalgia associated with the place we know as the *first* place, the *first* vision of things, the *first* clarity of things.... The images of prairie man are images of a search for home and a search for the self."[11] "Manitoba Mountain" (1968) and other representations of childhood, then, are not merely nostalgic memories. They are part of Kurelek's creation of a new past, part of his search for himself, a coming to terms with his own past by recreating it. Though he lived in downtown Toronto longer than he lived anywhere else, Kurelek's imaginative home always remained "the same palatial timber house at the end of the lane near Stonewall, Manitoba."[12] "Spring Work on the Farm" (1963) is one of many recreations of it. As a boy he had felt a special, even mystical, attachment to the bogland just east of his father's farm,[13] and when he returned there in 1963 he wrote his friend, Av Isaacs, while painting on that bog, that "the vastness of the prairies with occasional clumps of poplar bushes really gives me a feeling of communion. No one seems to understand why I am fascinated by this place not even the local people. Only I it seems can express it though others may feel it inarticulately."[14] "Testing the Spring Run Off" (1971)—here was home, what the Spanish call *querencia*, the contentment of familiar surroundings. A sense of identity.

Childhood and the prairies are inseparable in Kurelek's paintings. Yet the prairies are a theme in themselves. There are people, mainly easterners, who think of the prairies as flat land. But the prairies are much more than that. The opening lines of *Who Has Seen the Wind* are exact: "Here was the least common denominator of nature, the skeleton requirements simply, of land and sky—Saskatchewan prairie."[15] Kurelek's "Prairie Snow Plow" (1973-74) catches that least common denominator in a modern perspective. In "The Field Where I Was Born" (1966), the artist himself is almost insignificant in a winter prairie landscape reminiscent of John Newlove's lines.

On a single wind, followed
by lonely silence, the snow
Goes by. Outside
everything is gone; the white
sheer land answers no questions
but only exists.[16]

Land and sky—"over the segmented circle of earth," Wallace Stegner wrote, "is domed the biggest sky anywhere,"[17] as seen in "Repairing the Binder Gear" (1968). Another writer

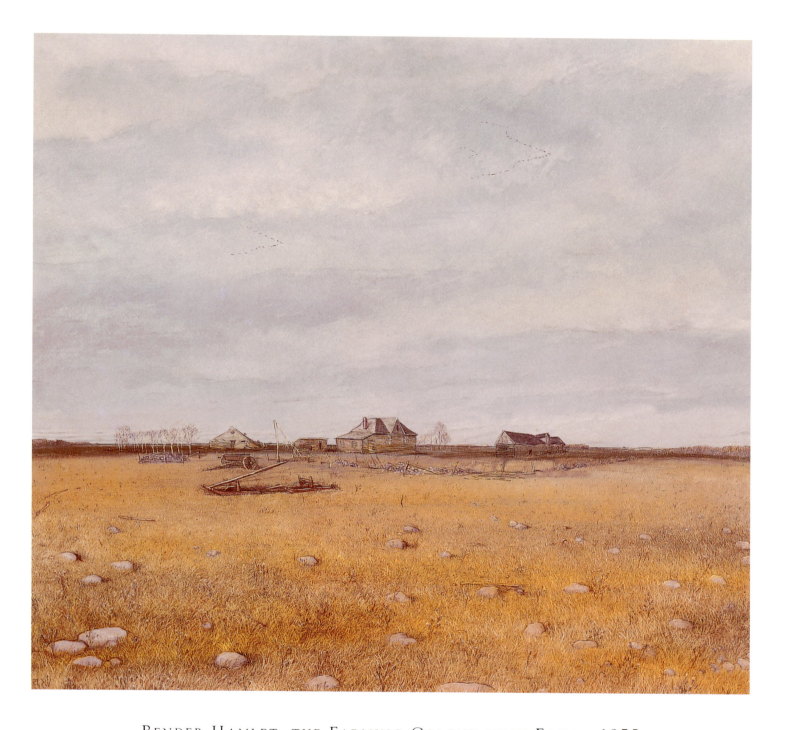

BENDER HAMLET, THE FARMING COLONY THAT FAILED 1975
Jewish Farming Colony, Manitoba Series
Mixed Media
Dimensions: 31 x 33 inches

who grew up on the prairies, Fredelle Maynard, remembered the earth and sky and its impact: "the image of man as a lonely traveller, moving through a universe," as in Kurelek's "Wintertime North of Winnipeg" (1962), "neither hostile nor friendly but only infinitely remote."[18] Kurelek's view of the universe was not quite so benign; he had lived too long on the farm to take that view. Land and sky at night are the backdrop to his version of the Owl and the Pussycat, which he entitled "Then One Fall Tom Did Not Return."

Kurelek knew that the prairie landscape had left its mark on him. He set out his experience during a painting trip in 1966:

I wanted to put in plenty of sky which with the blustery took all kinds of interesting aspects. At first I thought I'll leave it till tomorrow for fear I'd not have enough daylight time to do the driftwood. But I love doing skies (this I'd discovered on the bog in Manitoba) and I couldn't resist starting it anyway. Almost miraculously the sky took over. I worked fast, loosely, intensely with big brush, a color soaked rag and a dry rag. I could hardly believe my eyes how it turned out. This is real creativity which God's blessed me with.[19]

There was no end to the ways in which Kurelek could present the ever changing prairie sky and the almost equally numerous activities of the people who lived under it. His "Stooking" (1962) catches the ideal autumn harvest sky for which the farmer prays. "Spreading Manure—Winter" (1963) exudes the freezing temperature of that icy sky, while "Ukrainian Orthodox Easter Vigil" (1963), with its twinkling stars, evokes early spring on the prairies. It was not only the prairie sky that Kurelek could recreate with his brush. Neither the Moscow sky above St. Basil's Cathedral and the Kremlin in "Mission to Moscow" (1973) nor the rain-laden atmosphere engulfing a northern Ontario lumberman in an autobiographical picture entitled "The Fanatic" (1973) were beyond his exceptional talent. And yet it was the prairie—earth and sky—that he interpreted best. In 1967 he completed one of his finest prairie works: the clear line dividing sky and earth, the shadings of green and black rectangular fields with the twister, or whirlwind, or windspout—what the Ukrainian settlers imaginatively called "The Devil's Wedding."

Kurelek was fascinated with the history and lore of the Ukrainian people, for he always felt part of that community. And it is the history of settlement, especially of the Ukrainian settlement, that constitutes the third of Kurelek's visions. Indeed, one of the greatest achievements of his art was that it gave recognition to the part Ukrainian Canadians played, their sacrifices and their achievements. He was pleased that he had done so. After a large gathering of Alberta Ukrainians to honour him in 1966, he wrote: "I was overwhelmed at

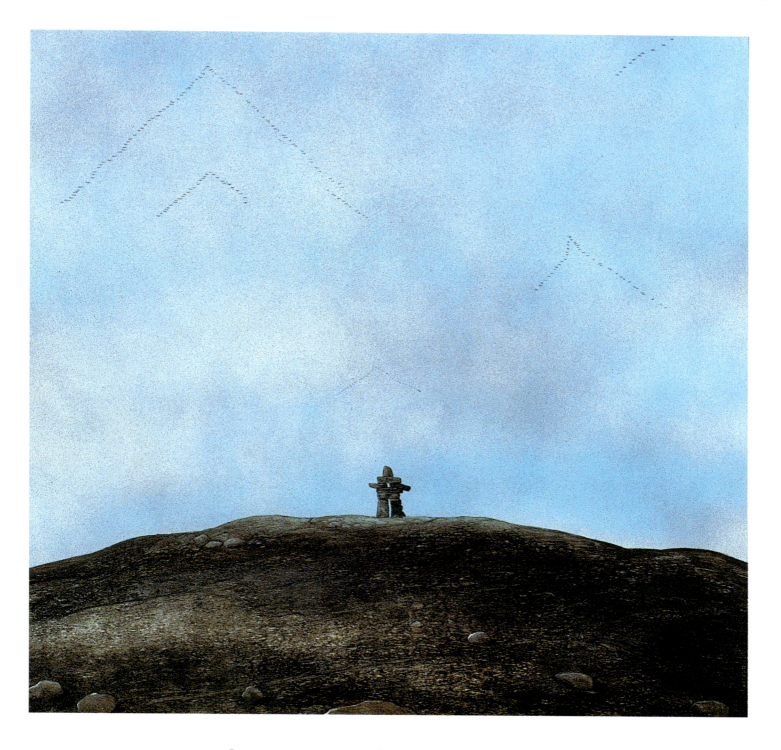

INNUKSHUK AND CANADA GEESE 1977
Big Lonely Series
Mixed Media
Dimensions: 20 x 20 inches

the esteem they hold me in for the honour my work brings to Ukrainian Canadians."[20] Early in his life he had been touched by Ukrainian nationalism, and he had conceived the idea of painting a great epic illustrating his people's past.[21] Eventually he completed two unified series: "An Immigrant Farms in Western Canada" (1964), which told the story of his father's life, and in 1967, "The Ukrainian Pioneer Woman in Canada," based on his mother's history. In these series he depicted the concrete elements of a settler's existence in a manner that gave history a reality and a humanity that is impossible to convey on the printed page. In "Leaving the Old Country" (1964), the immigrant set out across an unknown ocean to a strange land. On his newly acquired homestead he built "A Boorday—the First House" (1966), and when fortune smiled "The Second House" (1966) followed. There was much hard work, and life had few frills. "The Honeymoon" (1963), for example, was a splendidly ironic painting. The happy bride was carried off, not to the bliss of a newlywed's vacation, but to the rude farm house, no doubt in time to do the evening chores, as depicted in "Farm Wife Pumping Water for Cattle in Saskatchewan" (1968).

But there were celebrations, too. Kurelek's "Ukrainian Canadian Farm Picnic" (1966), with its striking resemblance to Bruegel's "Peasant Wedding Dance" painted four hundred years earlier,[22] exemplifies the joy of escape from rural routine. And then there were the beliefs and customs brought from the homeland. "Green Sunday" (1962), depicts the first Sunday in May, when the poplar branches are placed in the corners of the living room. "Ukrainian Christmas Eve Supper" (1958) shows the hay beneath the table and the twelve dishes, one for each Apostle, set before the wide-eyed child. "Blessing the Easter Paska" (1966) once again displays Kurelek's rootedness in the prairie soil, for it catches skillfully those two temples of western Canada: the onion-domed church and the angular grain elevator. Finally, there are two paintings that demonstrate Kurelek's awareness of the part that women played in pioneer life. "Mama" (1966-67) is a series of detailed cameos, each displaying an aspect of woman's work and responsibility. "A First Meeting of the Ukrainian Women's Association of Canada in Saskatchewan" (1966) is specifically Ukrainian in reference. Yet it reveals a great deal about prairie history: the country school with its inadequate stove, and the women gathered to form an organization to break down the isolation around them and to protect the community from powers outside.

Kurelek, characteristically, was not satisfied to chronicle in paint the trials and triumphs of his people as they settled the west. He had to ask himself what it all meant, whether the achievements were real and ultimately worth the struggle. Baba, grandmother, remembered it all: the sacrifices of the first generation, the affluence of the present one. "Now the fields are lush and productive," Kurelek wrote, explaining a picture entitled "Material Success,"

symbolic of this land of plenty. All the latest gadgets and furniture fill the house. The older children are educated in university and useful trades. The babies and

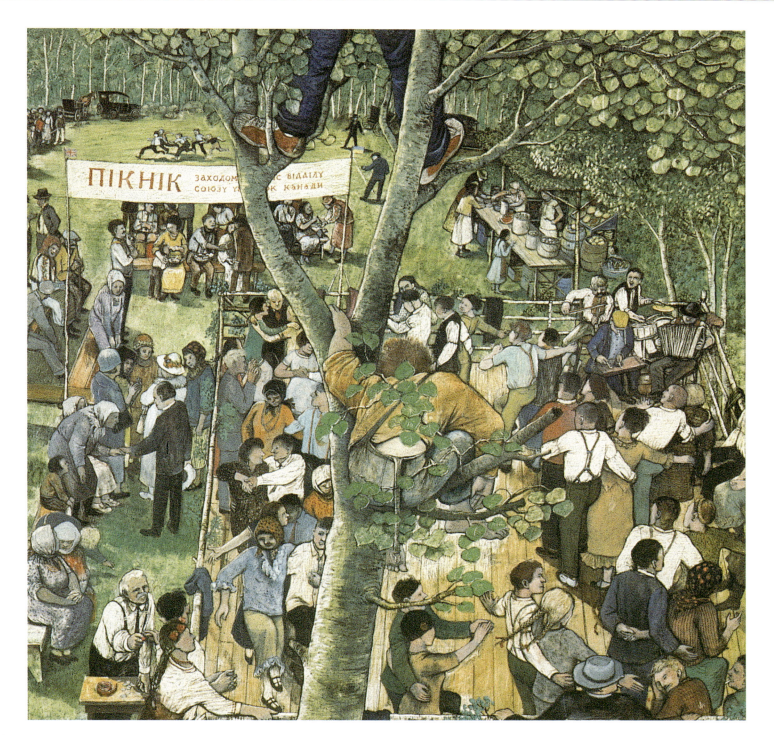

UKRAINIAN CANADIAN FARM PICNIC 1966
The Ukrainian Pioneer Woman in Canada Series
Oil
Dimensions: 27 ¾ x 27 ¾ inches

youngsters are healthy, fattened by vitamin-conscious parents. And they still retain some of their cultural heritage.

So where to now? The same eternal question pursues man no matter how many thousands of miles he wanders to put in new roots. What does it profit a man if he gains the whole world yet suffers the loss of his soul?[23]

That was the same question that formed the heart of the conflict between Joseph and Sandor Hunyadi, father and son, in John Marlyn's rich novel of immigrant life, *Under the Ribs of Death*.[24] In his own life Kurelek had answered that question.

Kurelek's desire to paint the history of his people did not limit his interest in other Canadians any more than his preoccupation with the prairies caused him to exclude other aspects of Canadian life. In fact, from the beginning of his career he was fascinated by urban subjects, seeking out city life in all of its facets. His "O Toronto" series of 1973 was only one example.[25] A later series on Montreal was further evidence of his artistic breadth. "Toronto Slums" (1968) leaves no doubt that Kurelek was fully aware of the immediate world around him; social decay and poverty were as real to him as pioneer farm life. "It's Hard for Us to Realize" (1972) again displays his strong emotions about the inequalities and injustices of modern urban life. Nor were these concerns confined to Canada. His 1969 trip to India resulted in a series of powerful drawings on the social problems of developing countries. "Deformed and Destitute in India" (1969) is a graphic example. So, too, he urgently wanted to paint a complete picture of the Canadian ethnic mosaic, celebrating the contributions of the Inuit, Irish, Jews, French Canadians and others. "Father O'Connell and the Poles of Sydney," painted in 1977, attests to the impressive range of Kurelek's artistic talents and human sympathies.

Yet it is surely true that Kurelek's perspective remained the one formed on the prairies. This is not a criticism. Reading the text of *Kurelek's Canada*, a series intended to illustrate life in every region of the country, one again senses the prairie lens through which the artist saw his country. That is what gave the series its authenticity. Commenting on two Nova Scotia lobstermen greeting each other from distant boats, he wrote: "The feeling is somewhat akin to the warm glow a prairie farmer gets from seeing a far-off neighbour's farm house lights come on in the evenings."[26] Kurelek's imagination was rooted in his region, and that is what makes him so identifiably Canadian in a country where culture has always had regional roots.[27]

In his later years Kurelek also came to realize more and more that his artistic vision was nourished by his Ukrainian heritage. For a time he turned his back on the Ukrainian nationalist ideology of his youth, first as part of his Joycean revolt against his past, and later because of his attraction to Great Britain. But the experience of painting his two great Ukrainian pio-

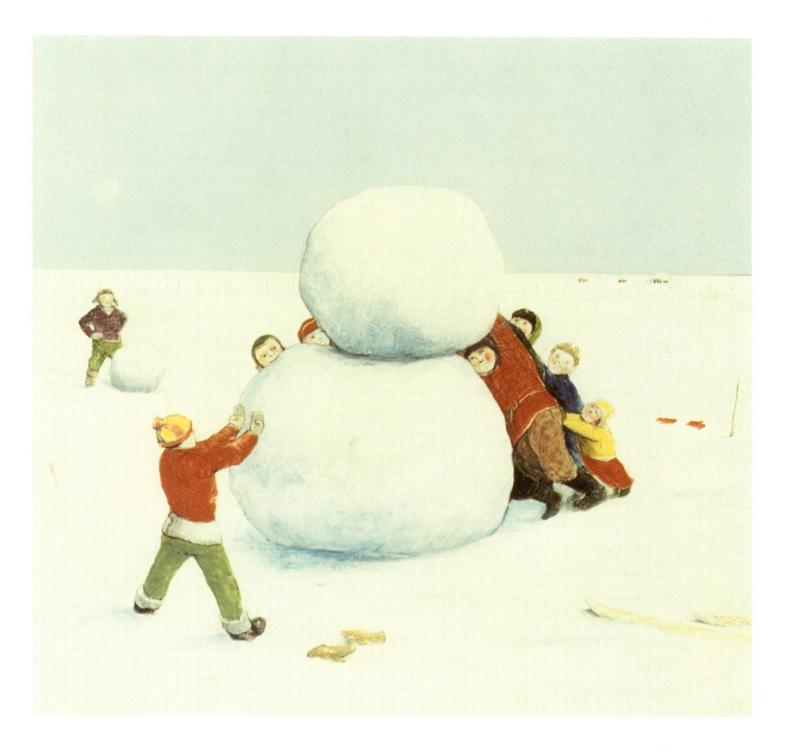

PICTURE OF CHILDREN BUILDING A GIANT SNOWMAN, MANITOBA, 1970

neer series reawakened his ethnic identity. Then in the early 1970s he made his first trip to Ukraine, where he was permitted a brief, but profoundly moving, visit to his father's native village. "In those four hours I saw, however fleetingly, the houses in which the peasants lived, ate the food they ate, photographed the village pond and talked the language of my forebears. It was like living a lifetime in one day. Here were my ultimate roots.... This was the real Ukraine, not the attenuated version I had worshipped in my nationalistic days in Winnipeg." It was then that he conceived of a great mural depicting Ukrainian-Canadian history that would one day, he hoped, hang in Ottawa for all Canadians to see. This was the project he was still working on during his last visit to his father's homeland just before his death.

Yet, if Kurelek's perspective was regional and ethnic, the central focus of his vision was religious. "Put God first and your national or ethnic origin second," he insisted.[28] That very determination to put God first was what most disturbed his critics and even his admirers. But those tenaciously held beliefs were what made him paint. Pictures without explicit religious content, the ones his public most enjoyed, he dismissed as "pot-boilers," and he was often frustrated in doing them. "Maybe I'm more like in my lumberjack days," he wrote in his diary in 1966,

> when I worked 7 days a week 12 hours a day except that it was backbreaking work.... These kind of paintings are somewhat like cords of wood in that I produce 2 1/4 a day like I produced 2 1/4 cords a day in good timber stands. I am aware that they are pot-boilers and cannot make them openly religious as I would like because they wouldn't be saleable.... I am much more fortunate than a great many people to-day because God has given me faith and I can see fairly clearly that even when I cannot openly testify to Christ I can at least give God glory obliquely by representing nature which He created and continues to hold in existence minute by minute by His omnipotence. Even when man in his partnership of creativity with Him fumbles in his share of the work, He goes on regardless. turning evil to good.[29]

Kurelek's conversion to Catholicism in England in 1957 was the single most important event in his life: the recurring, fierce pain in his eyes disappeared, he discovered that he could make friends more easily, and he came to a convincing understanding of the meaning of life. His cry, "Lord That I May See," painted in 1950 shortly after an attempted suicide, had been answered. A dozen years after his conversion, he documented the critical moment in his life in a frighteningly beautiful painting. He described its origin in his autobiography.

> On the third night or so after my transfer to Netherene my newly found interest in religion...was suddenly catapulted to the forefront by an awful experience. I awoke for no accountable reason some time after midnight and sat up in bed. The moon was shining brightly on the cabbage field outside our villa and the pine forest

beyond. Yet I was overwhelmed by a sense of complete and utter abandonment the like of which I could remember only in childhood or perhaps last of all during that awful first night in Winnipeg in the hotel....It was not so much like "little boy lost" but like "LOST IN THE UNIVERSE."[30]

He titled the painting "All Things Betray Thee, Who Betrayest Me." The title was drawn from a poem that provided a motif for many Kurelek works—Francis Thompson's "Hound of Heaven." Kurelek identified very closely with that poem's first stanza.

I fled Him down the nights and down the days;
I fled Him down the arches of the years;
I fled Him down the labyrinthine ways
Of my own mind; and in the midst of tears
I hid from Him, and under running laughter.
Up vistaed hopes I sped;
And shot, precipitated,
Adown Titanic glooms of chasmed fears,
From those strong Feet that followed, followed after.
But with unhurrying chase,
And unperturbed pace,
Deliberate speed, majestic instancy,
They beat-and a Voice beat
More instant than the Feet—
'All things betray thee, who betrayest Me.'[31]

In 1965 Kurelek translated "The Hound of Heaven" into a cloudless prairie scene. No one who has walked on a dark prairie road on a moonlit, almost summer night can fail to shudder.

Kurelek, even before his conversion, had painted religious paintings,[32] and shortly before returning to Canada he set out for the Holy Land, drawn as so many other Christian artists had been drawn,[33] to the theme of Christ's passion. Eventually that work became the magnificent series now hanging in the Niagara Falls Art Gallery.[34] In this series and in other explicitly religious paintings, he wanted to restate the Christian gospel in contemporary terms. His intention was not, as was sometimes said, to use his paintings to convert others. He was too sound a theologian for that: "Faith," he wrote, correcting a journalist who had written an article about him, "is a gift of God, usually given to those who are humble enough

to ask for it." Paintings could only be "teaching aids."[35] But to teach meant to make the message immediate.

Yet he knew also the dangers of didacticism. One of his finest paintings, "Dinner Time on the Prairies" (1963), was included in a series entitled "Experiments in Didactic Art." A note he scribbled made plain his determination to give immediacy to Christian precepts:

> This is an intuitive painting. I was wondering how to paint a western religious painting and suddenly this idea came to me, so it is open to interpretation. A meaning I put on it is that which crucifies Christ over and over can just as easily happen on a summer day on a Manitoba farm as anywhere else. The farmer and his son doing the fencing may have had an argument just before dinner or one of them may have enjoyed a lustful thought. Or got an idea how to avenge himself on a neighbor etc.[36]

He knew that some critics would be unhappy about this kind of painting, even those who had praised his farm scenes, so he issued an explanatory manifesto, in which he pointed out that many artists—Bosch, Bruegel, Goya, Hogarth, Daumier and Diego Rivera—had painted pictures of a didactic kind, and they were accepted as great artists. "I don't pretend to put my work on a level with theirs," he explained with his usual modesty, "but I nevertheless do have something to say just as they did."[37]

The critics were not mollified by this explanation, and Kurelek was obviously hurt. He considered offering only his "pot-boilers" for sale through commercial galleries and setting up a Christian gallery where he would show his didactic works and turn the proceeds over to Christian activities of a missionary and charitable kind.[38] But he certainly continued to produce didactic art. "The Atheist" (1963) might be mistaken for a simple prairie scene but for the title and the obvious suggestion of the parable of the sower. "Our High Standard of Living" (1965) commented upon the corruption of a Christian festival and revealed Kurelek's social conscience.

In 1966, several leading Canadian critics expressed strong negative reactions to Kurelek's religious and moralistic paintings. One, in an extraordinary sentence, declared that "the problem with these pictures is that they flow from Kurelek's imaginings and not from what he knows."[39] He urged the artist to confine himself to rustic scenes of peasant life. Kurelek replied in a lengthy, intense letter. His religious paintings, he said, had to be accepted as just as much a part of his vision as the farm paintings. He simply had to paint them. "If the world were a reasonably settled and happy place to-day I would probably be happily content to record the experiences of people on the land," he explained. "But it is not. Our civilization is in crisis and I would be dishonest not to express my concern about my fellow man." Even if the paintings were rejected by the critics and the public, he would continue to paint them,

for he felt compelled to expose the great problems of poverty, racism, sexual licence and general moral decay. Most important of all, he completely rejected the distinction between direct experience and "imaginings." "Did Hieronymous Bosch, a recognized master in representation of Hell himself go to Hell, and come back before he tackled it? No one has come back from the dead to record his experiences there and yet great classical writers like Milton and Dante waded right into it. Obviously they must draw their experience of those things partly from similar earthly experience partly from personal or mystical intuition."[40] "We Find All Kinds of Excuses" (1964) displayed what he meant by that combination of remembered experience and "mystical intuition."

Kurelek was almost obsessed with a sense of the precariousness of man's existence in the world. He had a recurring vision of the coming apocalypse, which he depicted in 1971 in a magnificent series entitled "The Last Days." He described what underlay his foreboding: "We all know that the nuclear weapons stockpiles are very real and those bombs have already been used on human beings. But what of the increasing violence, the rapid erosion of legitimate authority, the increasing poverty of the have-not nations coupled with the last-days-of-the-Roman-Empire kind of moral decay in the affluent West?"[41] That sense of doom could be presented sensationally or more quietly, as in the farm scene that evokes the familiar sights and smells of the quack grass burning in the prairie autumn. Its title, however, reveals what lay behind it: "One Man Taken, One Left as They Work Together in the Fields," drawn from the twenty-fourth chapter of St. Matthew.

The same ideas, and a greater sense of urgency, were expressed in 1973 in several paintings in the "O Toronto" series. There, included with scenes of neighbourhood streets, Massey Hall and the Humber River, were strongly stated attacks on abortion, commercial sex and materialism. Perhaps the central picture was "Harvest of Our Mere Humanism," depicting a "Bosch-like dream" of the fate of a secularized city: "the image of a grasshopper being eaten out by ants. I felt it represented our educational system." "Toronto, Toronto" explained the problem: a Bruegel-like crowd hurries by the steps of the old city hall, ignoring the Christ figure on the steps. "People either pay him lip-service only, or else they ignore him altogether."[42] "We Think Ourselves He-Men" (1965) makes the same point even more startlingly. Kurelek felt sure the day was coming when Christians would be forced to declare themselves against the world around them. "To-day, though Christians have lost social leadership, we are still tolerated," he wrote in the "Notes on the Last Days," "but as the morality of secular society grows ever more opposed to the Christian one, sooner or later concerned Christians will have to take a stand. And then they will be openly attacked."[43]

Kurelek's religious purpose is obvious enough in his explicitly didactic paintings. But it was also there in nearly everything else he painted. He was always looking for new ways to express his beliefs. He described the process in a 1965 diary entry during a painting trip to his father's farm.

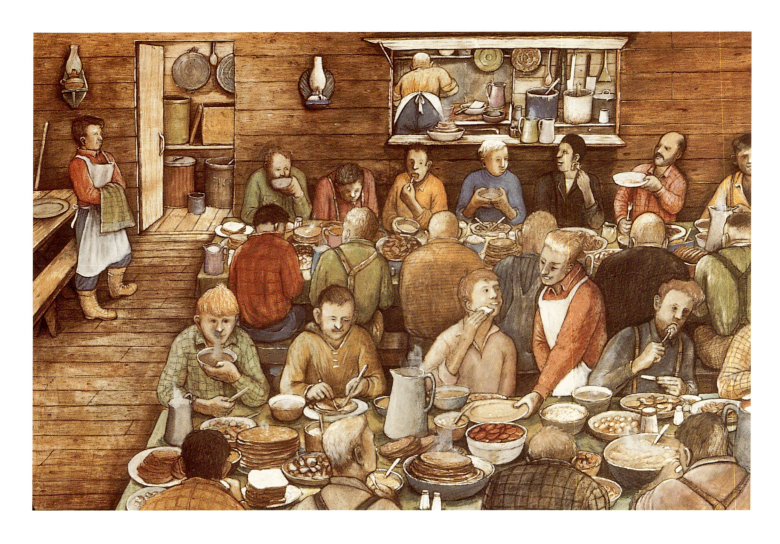

THE LUMBERJACK'S BREAKFAST 1973
Ontario and Quebec Bush Camp Memories Series
Mixed Media
Dimensions: 23 x 32 inches

I started painting a winter scene from Manitoba from a photo of a snow storm. I meditated a good while on what the theme of the picture would be and after a while it suggested itself to me. Cattle and birds are out in the storm and a boy hiding behind a smoke house. A line from Francis Thompson's poem "Hound of Heaven—Naught shelters thee, who wilt not shelter Me." I recall how in severe western winters nothing really sheltered man sufficiently except the heated farm house and so I compared it to a person in this life trying to find comfort in all sorts of places and activities forgetting that none will permanently shelter him but God. And his final resting place will be heaven. If he makes it.[44]

IV

CHILDHOOD, THE PRAIRIES, SETTLING AND CULTIVATING THE new land, Christianity: these are the great recurrent themes of William Kurelek's paintings. They all come together, so naturally, in a small lithograph done in 1973. In the foreground is the figure of the Christ-child standing in a field of tumbling Russian thistles. To the left two farm hands are sinking fenceposts, one of which is a crucifix. Near the horizon a tractor-drawn binder is at work, and further back the grain elevators and train smoke present a typical prairie skyline. To the right the forked lightning reaches down, directing attention to the man hurrying along the country road pursued by a hound. It is entitled "A Prairie Parable," and it contains the essence of Kurelek's vision.

A master painter teaches us to see the world in a new way, and in doing so he allows us to enter his imagination.[45] Tom Thomson taught us to see the Canadian Shield in his shapes and colours. David Milne gave us a world that is light and elusive, though no less clear for that. Jean-Paul Lemieux shows us a Québec where both people and landscapes have endured the centuries. Kurelek, too, provided us with a new way of seeing. His people move through a vast landscape, at work and play, in celebration and suffering, painted in a style that is at once naive and earthy and yet abstract. But abstract in the fashion of the mediaeval icon painters. "Only a great artist," says Mrs. Bentley in Sinclair Ross's classic prairie novel *As for Me and My House*, "only a great artist could ever paint the prairie, the vacancy and stillness of it, the bare essentials of a landscape, of earth and sky."[46] William Kurelek was that artist.

TEACHING UKRAINIAN 1967
Oil
Dimensions: 9 ½ x 8 ½ inches

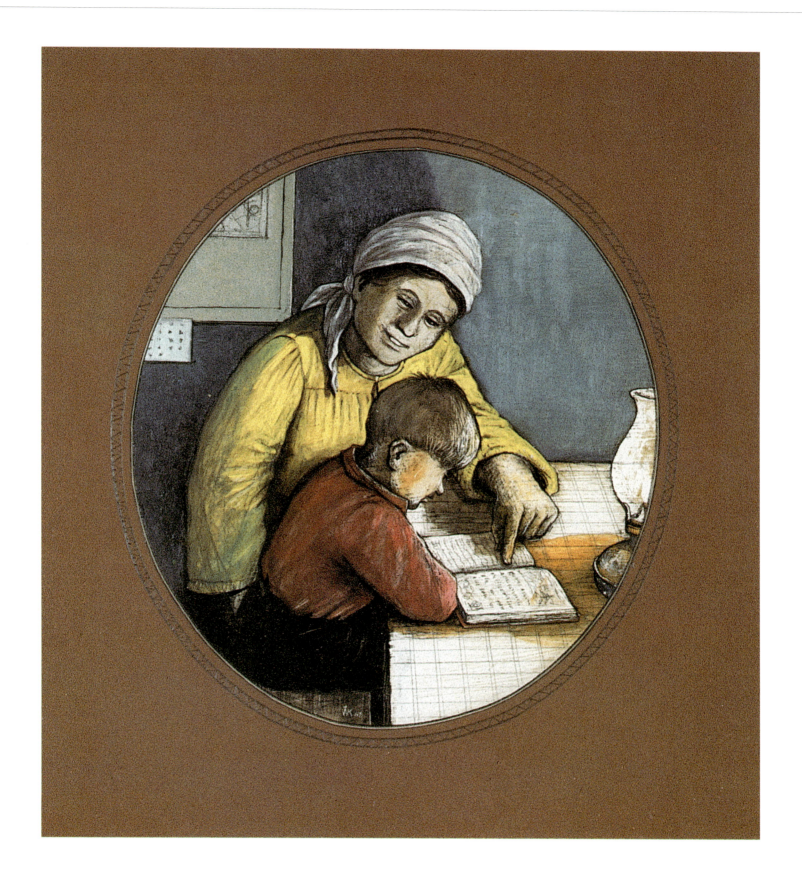

DRINKING WATER 1969
Prairie Farm Work Series
Oil
Dimensions: 18 x 27 inches

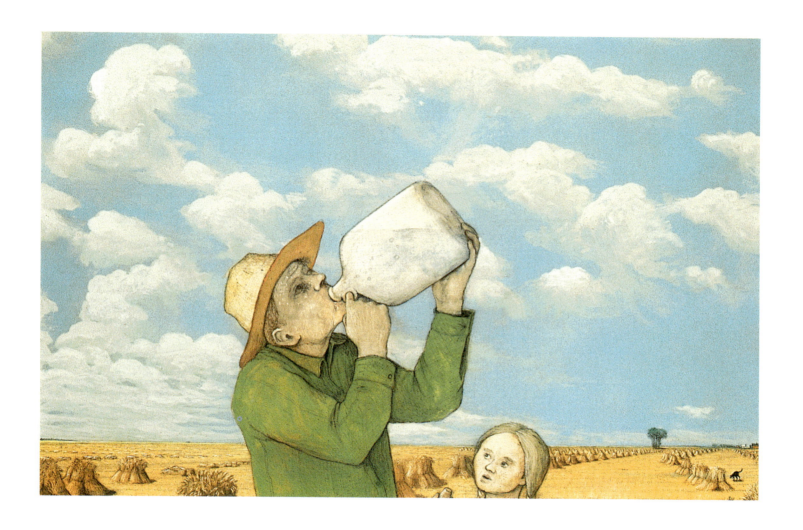

BIKE ACCIDENT AT THE OLD SWIMMING HOLE 1971
Humour Series
Mixed Media
Dimensions: 18 ¾ x 24 inches

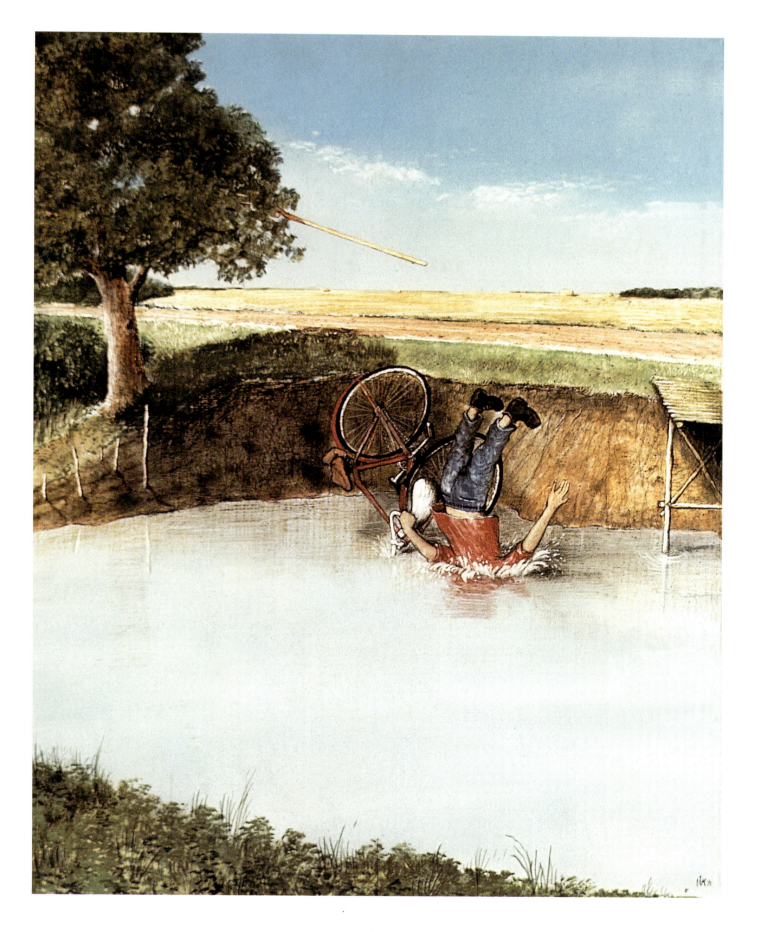

JEWISH BAKER'S FAMILY CELEBRATING THE
SABBATH IN EDMONTON 1975
Jewish Life in Canada Series
Mixed Media
Dimensions: 24 x 12 inches

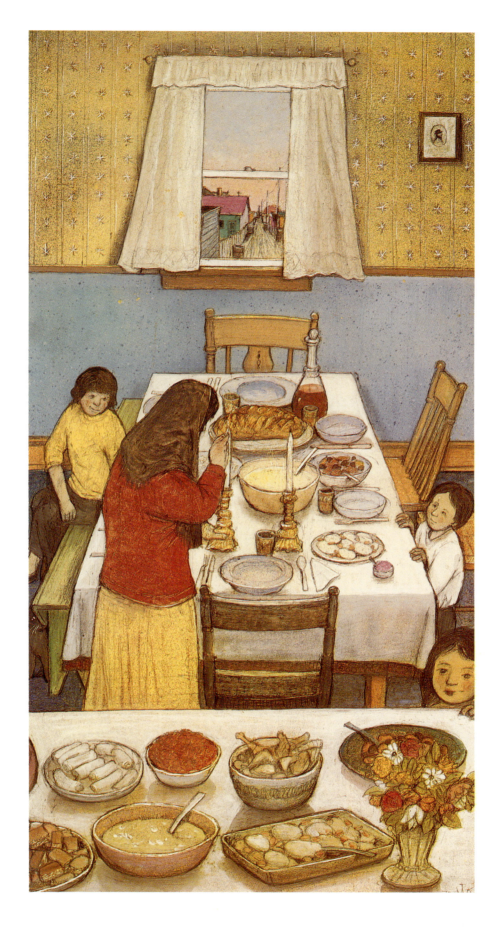

SCHOOL LUNCH UNDER THE WOODPILE 1974
A Prairie Boy's Summer Series
Mixed Media
Dimensions: 14 x 14 inches

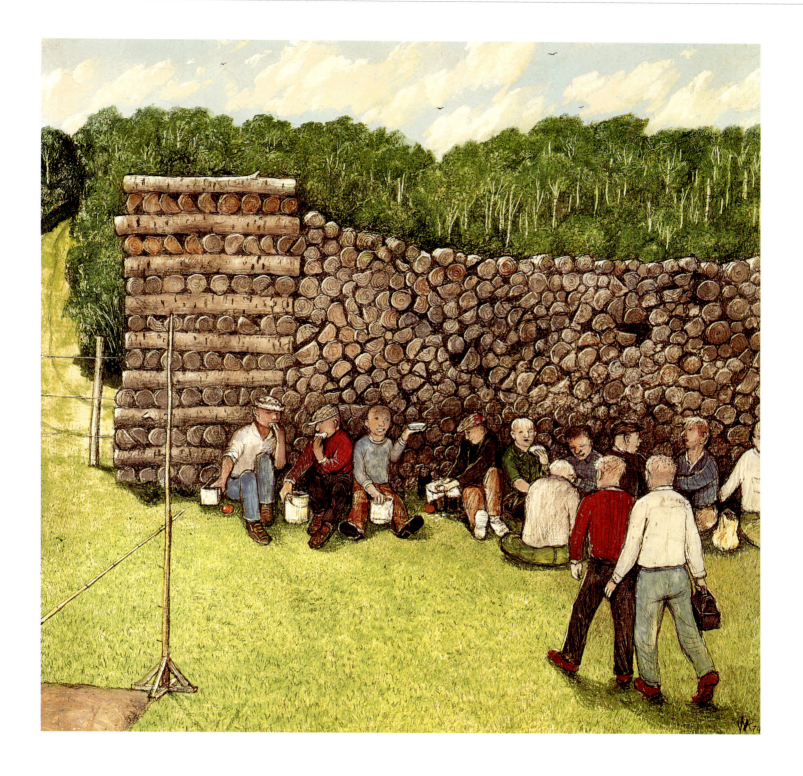

WAITING FOR THE SCHOOL BUS 1976
Rural Quebec Today Series
Mixed Media
Dimensions: 22 x 28 inches

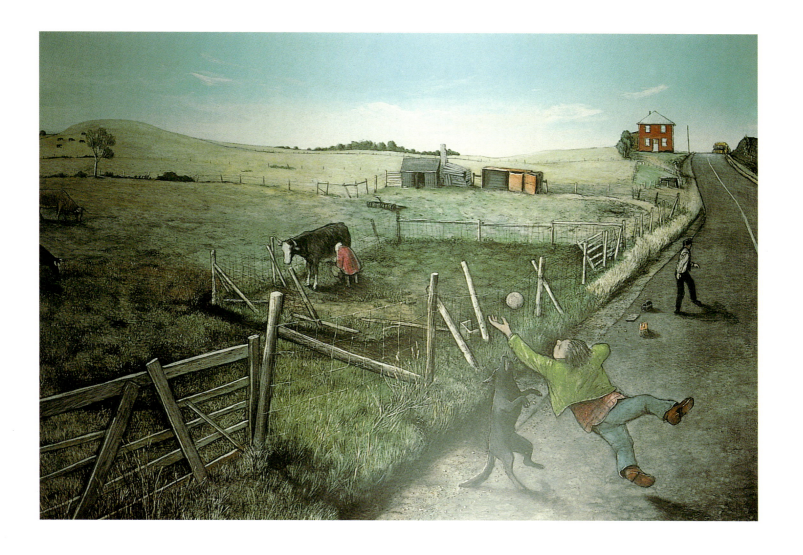

SISTER SERAPHIA VISITING PUPILS, TORONTO 1911
1976
The Irish in Canada Series
Mixed Media
Dimensions: 20 x 40 inches

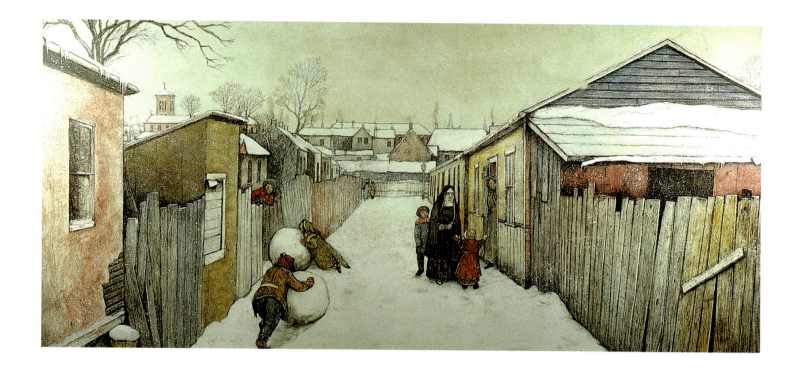

CANDY FLOSS CLOUDS 1977
Mixed Media
Dimensions: 20 x 20 inches
Collection: The Isaacs Gallery

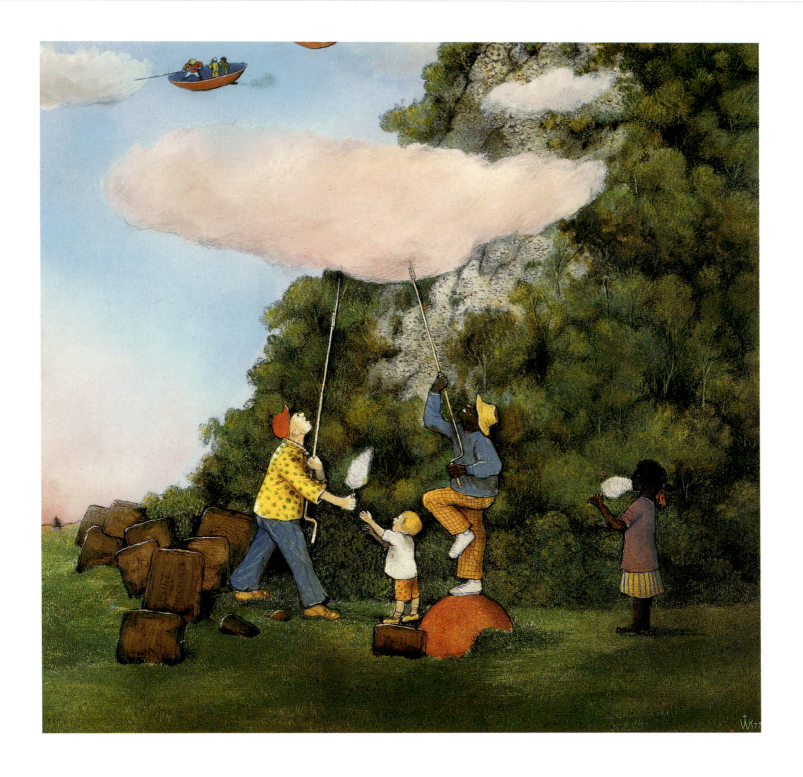

ONE ROOM SCHOOL AT KAS ZUBY 1977
The Polish Canadians Series
Mixed Media
Dimensions: 28 x 20 inches

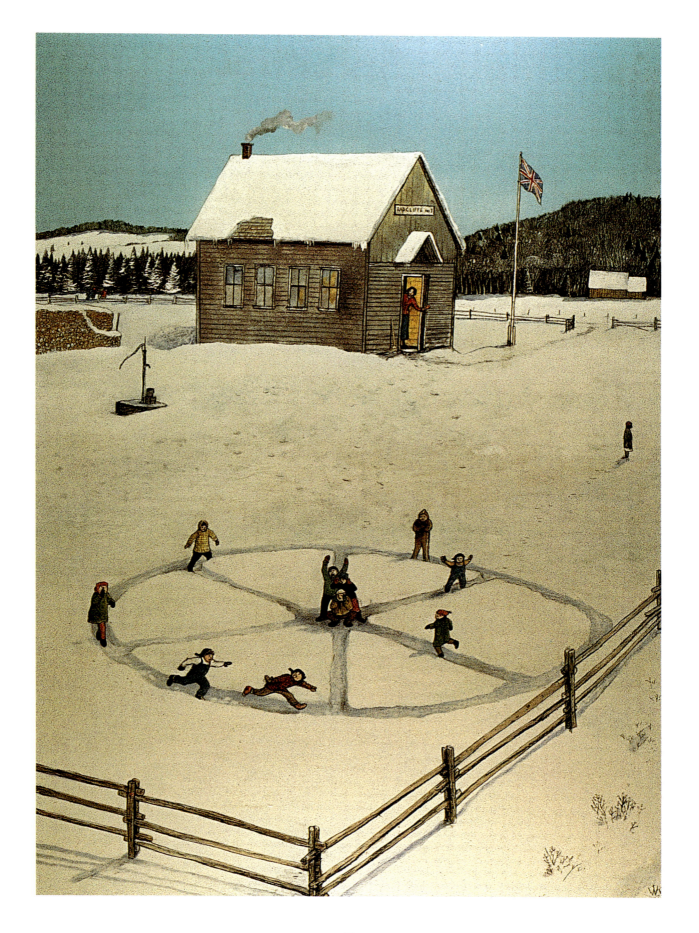

WINTERTIME NORTH OF WINNIPEG 1962
Farm and Bush Life Series
Mixed Media
Dimensions: 40 x 56 inches

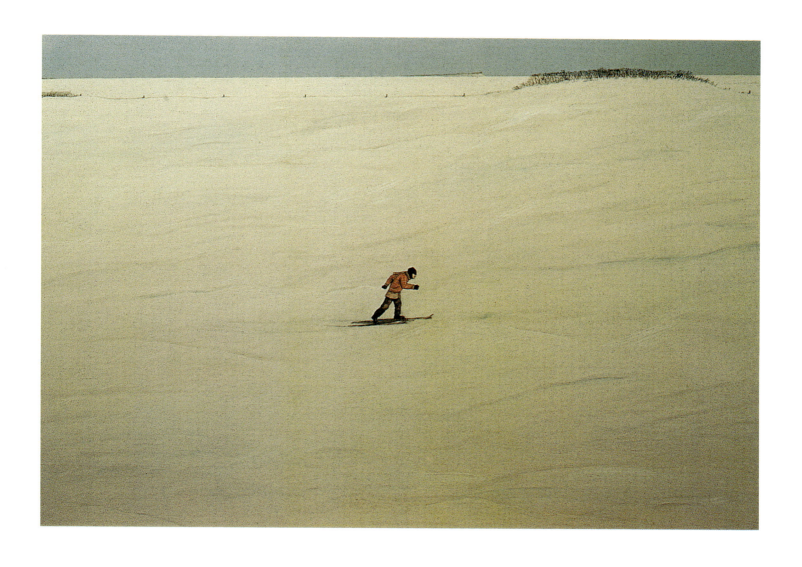

HAIL STORM IN ALBERTA 1961
Oil
Dimensions: 27 x 19 inches
Collection: Museum of Modern Art, New York

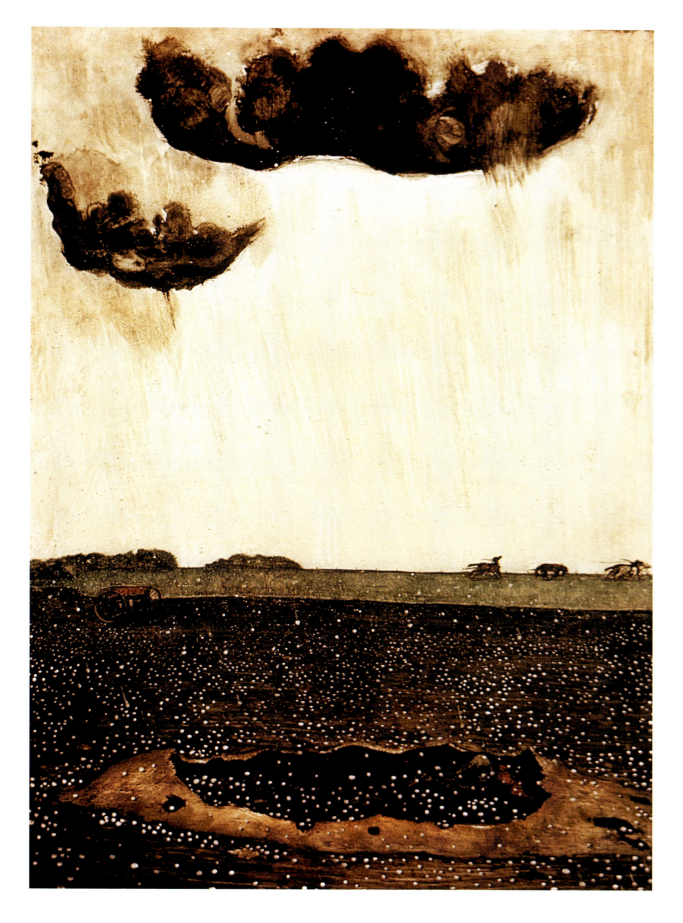

SNOW CRACKS IN THE BAY 1968
Cape Dorset Series
Mixed Media
Dimensions: 29 x 6 inches

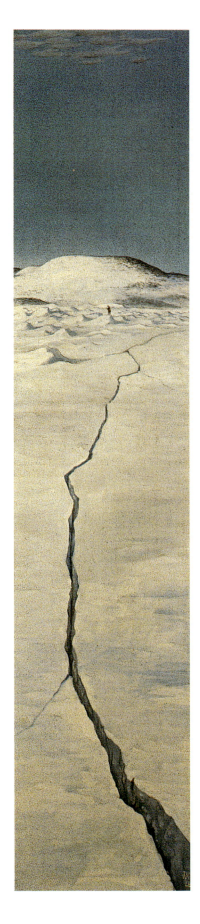

CAPE DORSET IN THE SNOW STORM 1968
Cape Dorset Series
Mixed Media
Dimensions: 18 x 23 ½ inches

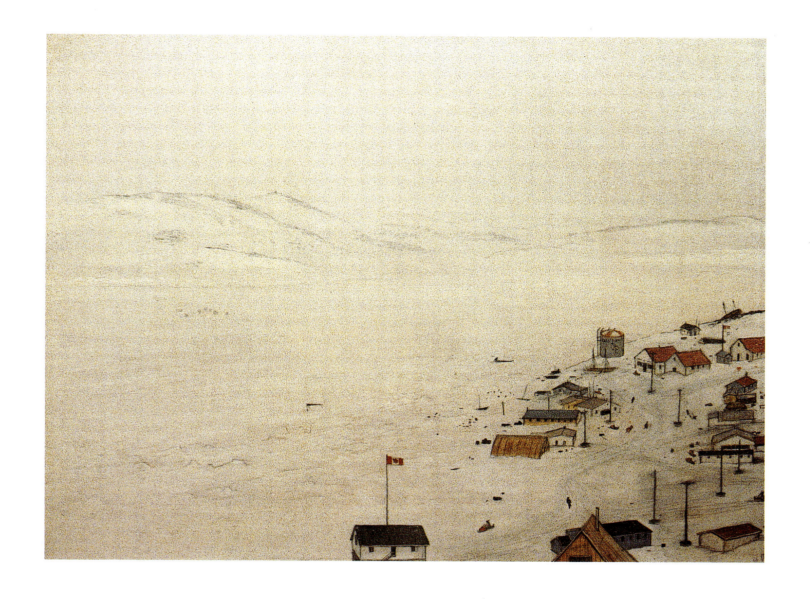

PRACTICAL JOKES IN THRESHING TIME 1969
Prairie Farm Work Series
Oil with Watercolour Tint
Dimensions: 22 x 11¾ inches

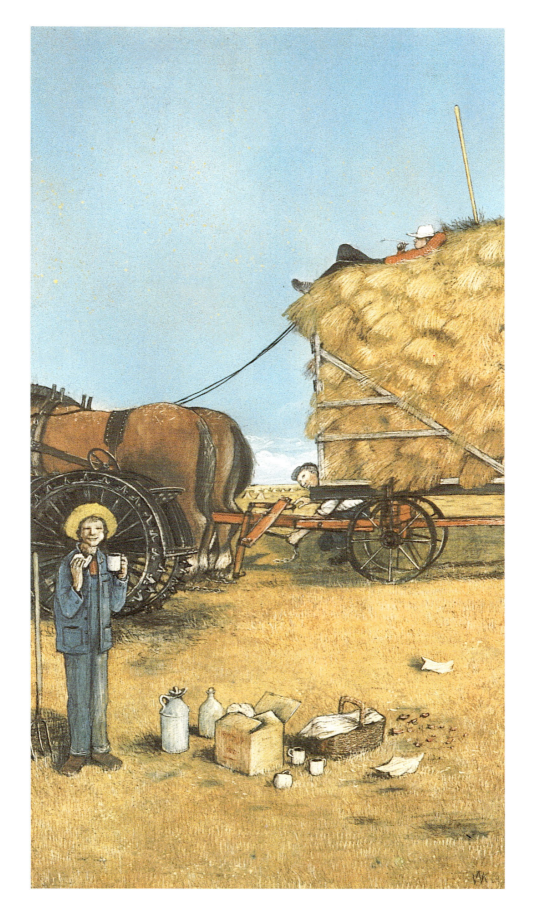

ABANDONED RAILROAD IN CAPE BRETON ISLAND 1973
Mixed Media
Dimensions: 48 x 23 inches

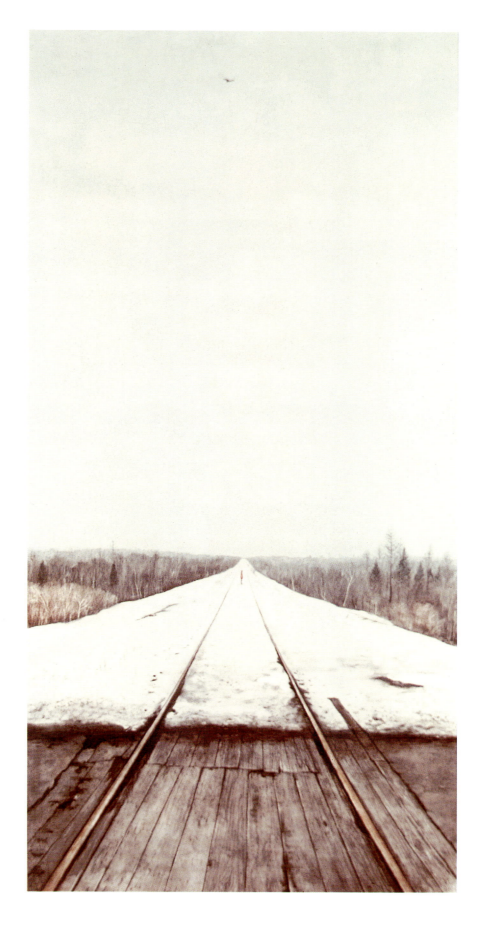

APPROACHING GROUSE MOUNTAIN 1973
A Prairie Artist Paints the Mountains Series
Mixed Media
Dimensions: 29 ½ x 17 ⅝ inches

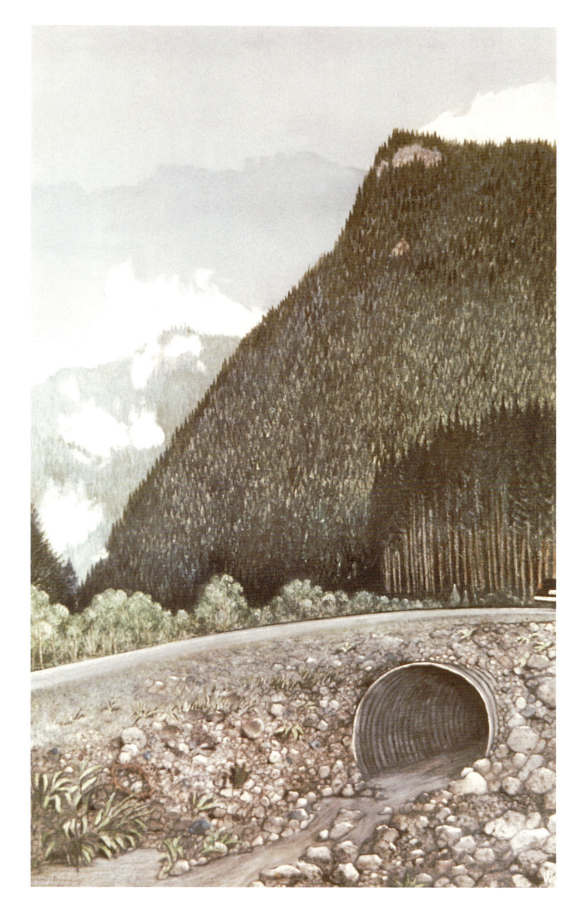

TRUSTEES MEETING ON THE BARBER FARM, REGINA 1976
The Irish in Canada Series
Oil
Dimensions: 24 x 48 inches

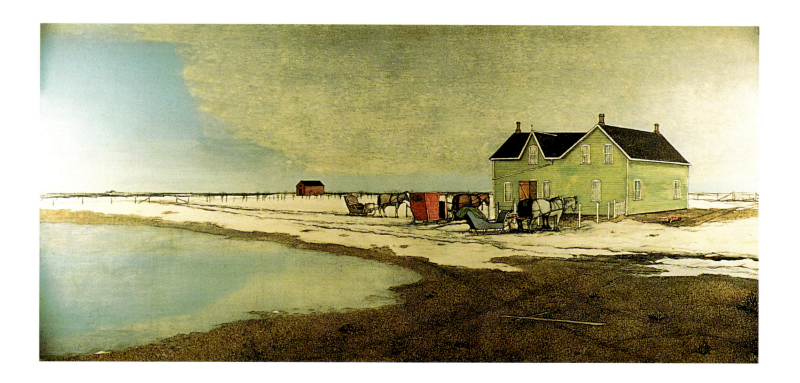

An Irish Settler's First Big Potato Harvest 1976
The Irish in Canada Series
Mixed Media
Dimensions: 24 x 48 inches

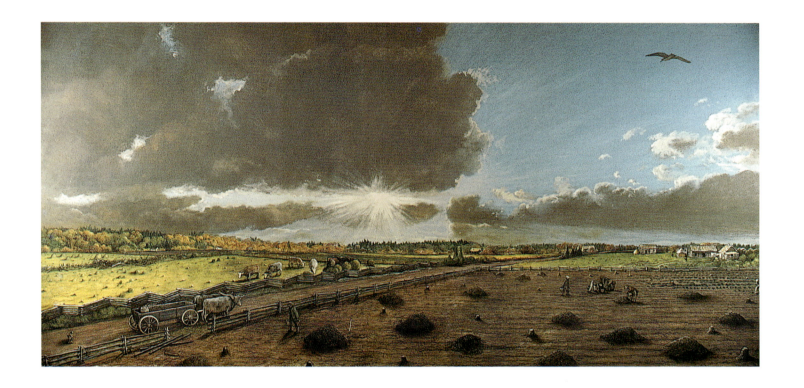

First Snow from the South 1976
Rural Quebec Today Series
Mixed Media
Dimensions: 28 x 22 inches

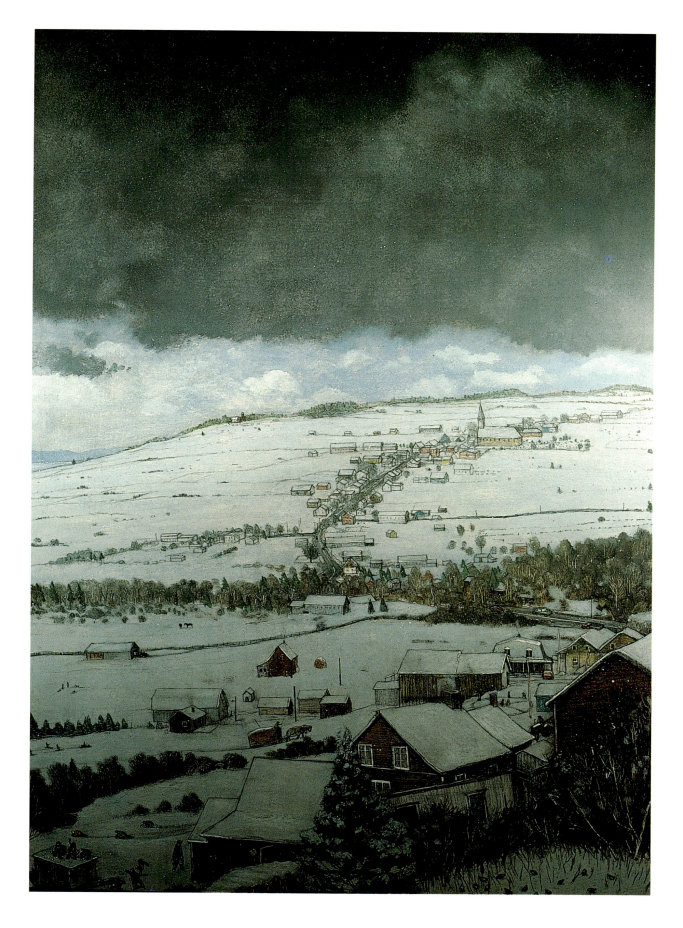

THRESHING ON THE ST. LAWRENCE 1976
Rural Quebec Today Series
Mixed Media
Dimensions: 22 x 28 inches

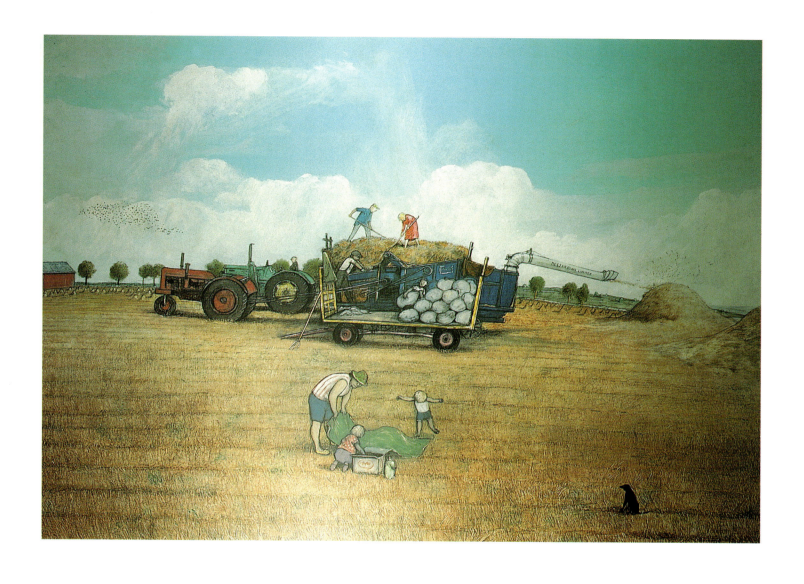

YUKON TRAPPERS' STOP 1977
Big Lonely Series
Mixed Media
Dimensions: 24 x 7 ¾ inches

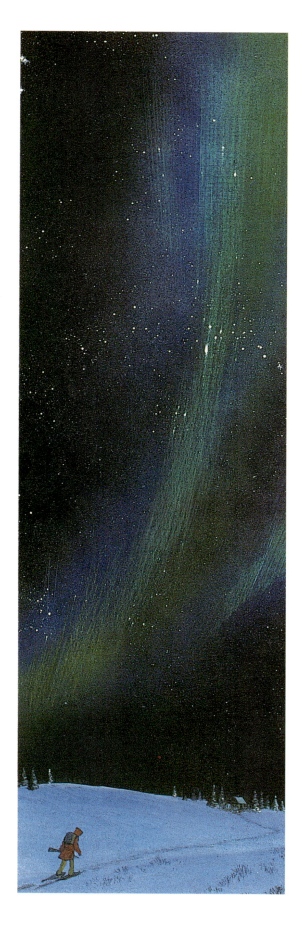

DRIVING TO WINNIPEG 1977
Big Lonely Series
Mixed Media
Dimensions: 24 x 7 ¾ inches

NIGHT HUNTERS 1977
Big Lonely Series
Mixed Media
Dimensions: 12 x 20 inches

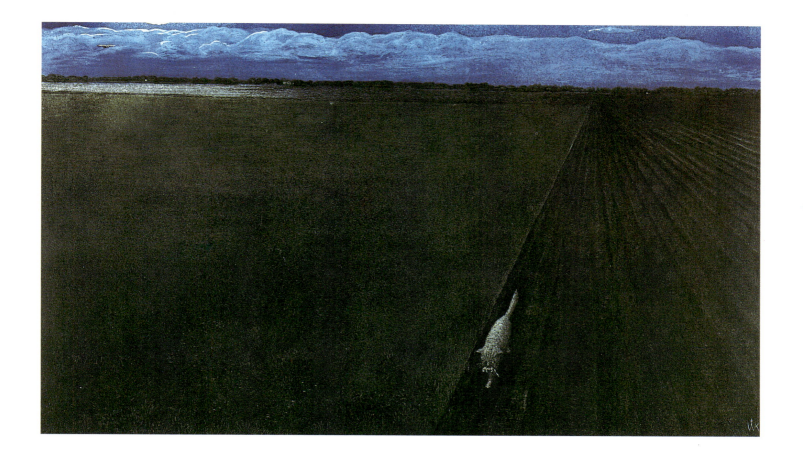

But How Is It That You Cannot read
the Signs of These Times? 1975
Field Series
Mixed Media
Dimensions: 40 x 28 inches

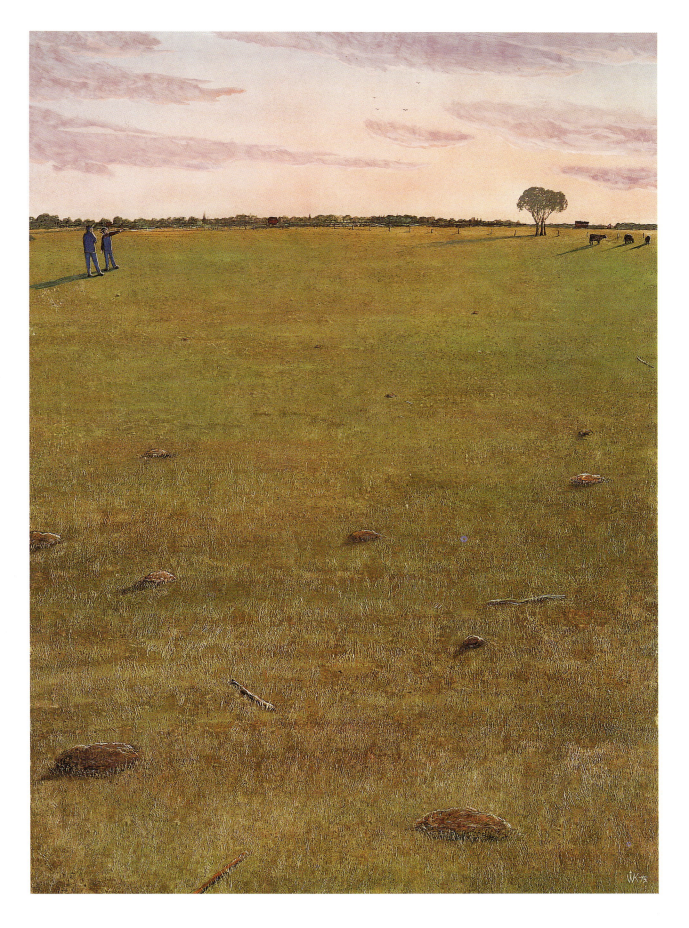

First Sight of Canada at Halifax 1964
An Immigrant Farms in Canada Series
Oil
Dimensions: 25 ¾ x 15 ½ inches

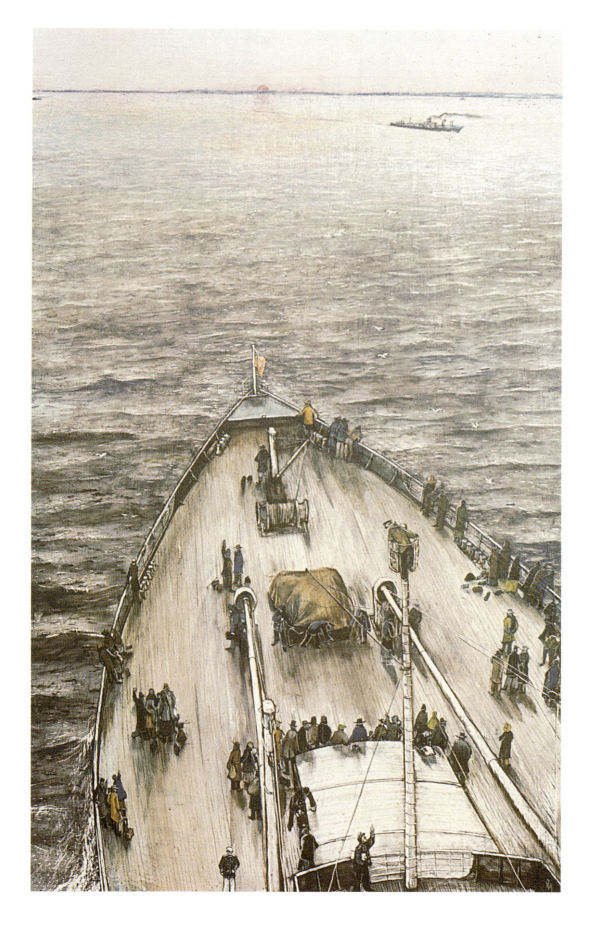

Manitoba Party 1964
An Immigrant Farms in Canada Series
Oil
Dimensions: 48 x 60 inches

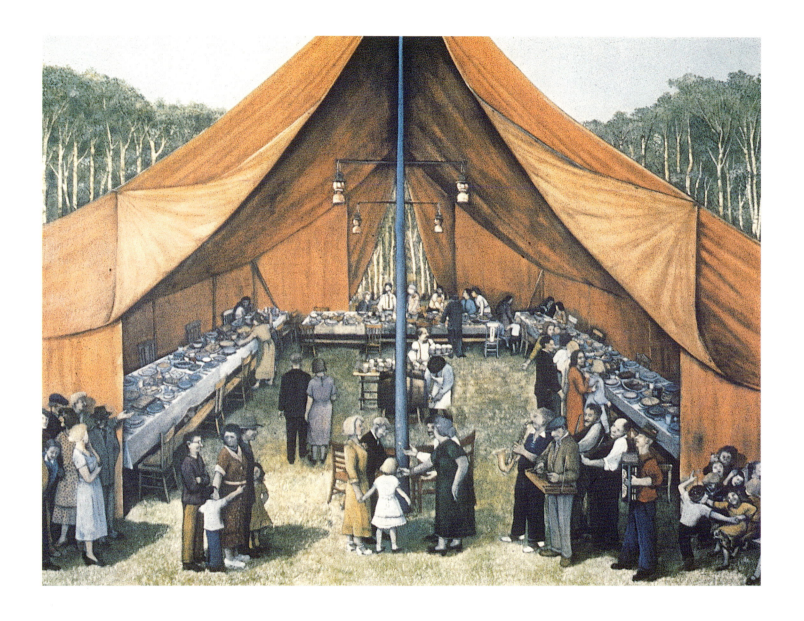

A First Meeting of the Ukrainian Women's Association of
Canada in Saskatchewan 1966
The Ukrainian Pioneer Woman in Canada Series
Oil
Dimensions: 24 ½ x 31 inches

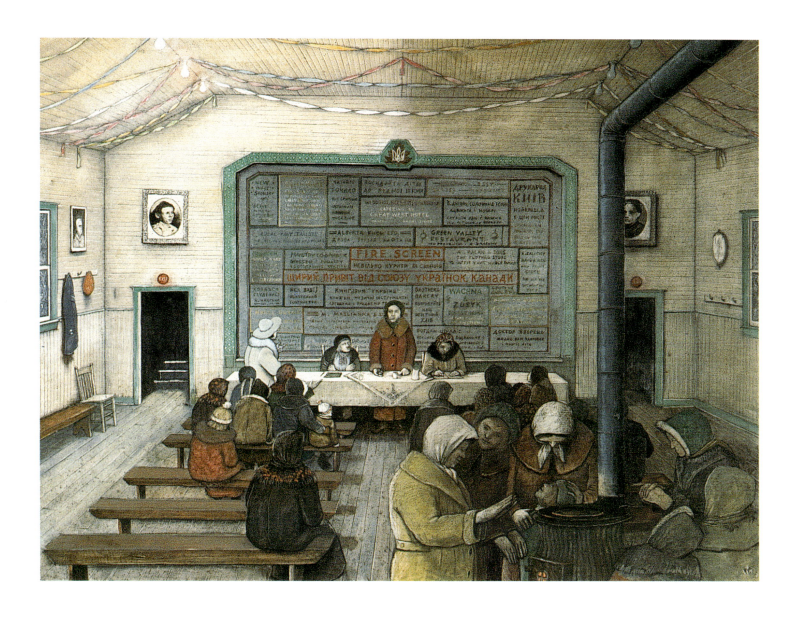

Jewish Dairy Farm Outside Winnipeg
1975
Jewish Life in Canada Series
Mixed Media
Dimensions: 16 x 28 inches

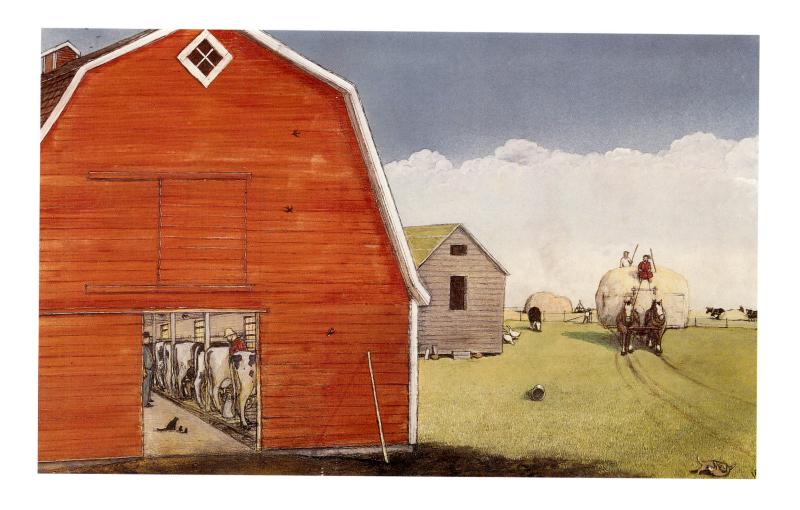

JEWISH SCRAP COLLECTOR QUESTIONED BY A TORONTO POLICEMAN
1975
Jewish Life in Canada Series
Mixed Media
Dimensions: 16 x 28 inches

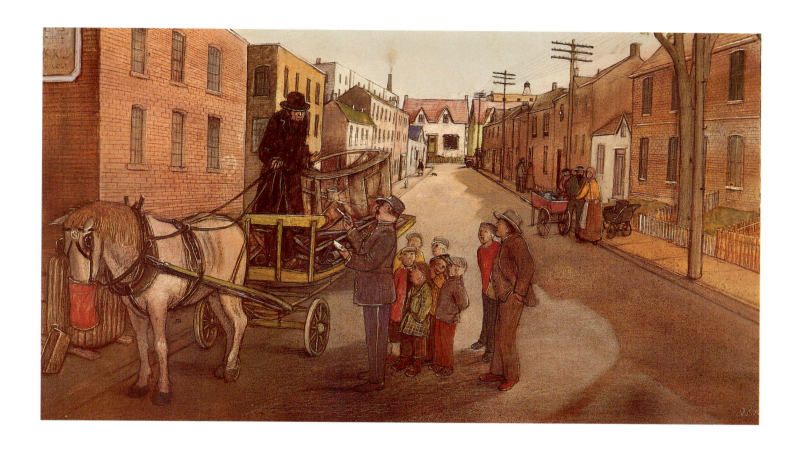

GENERAL STORE IN VANCOUVER BEFORE WORLD WAR ONE 1975
Jewish Life in Canada Series
Mixed Media
Dimensions: 12 x 16 inches

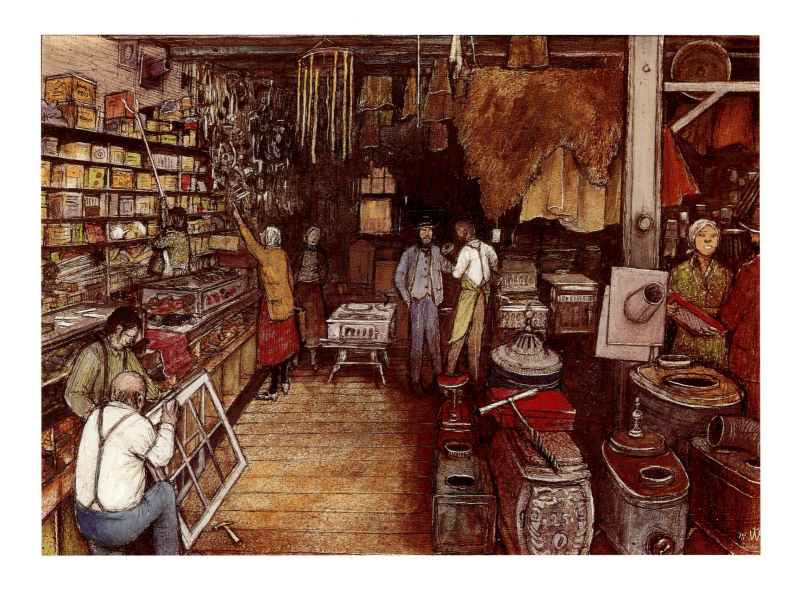

Paul Kane Among the BC Indians 1976
The Irish in Canada Series
Mixed Media
Dimensions: 48 x 24 inches

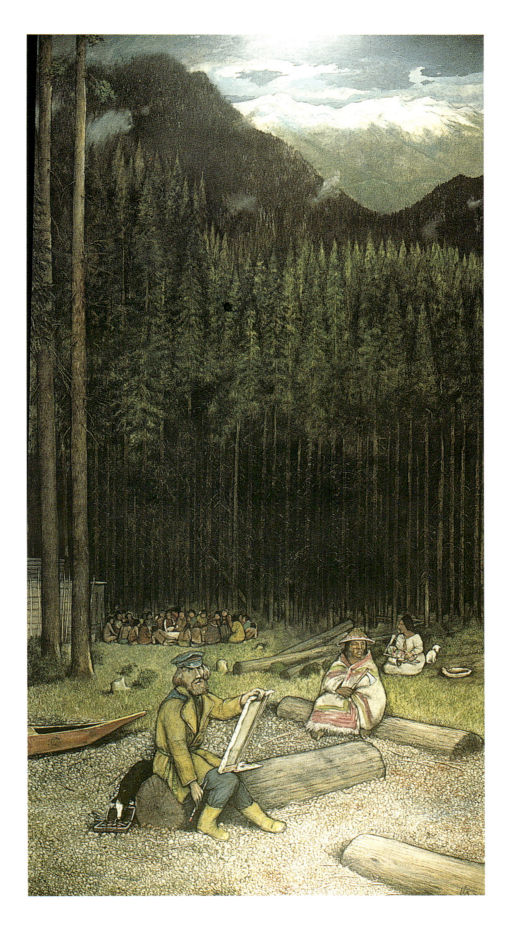

Retired Sea Captain, Newfoundland 1976
The Irish in Canada Series
Mixed Media
Dimensions: 24 x 24 inches

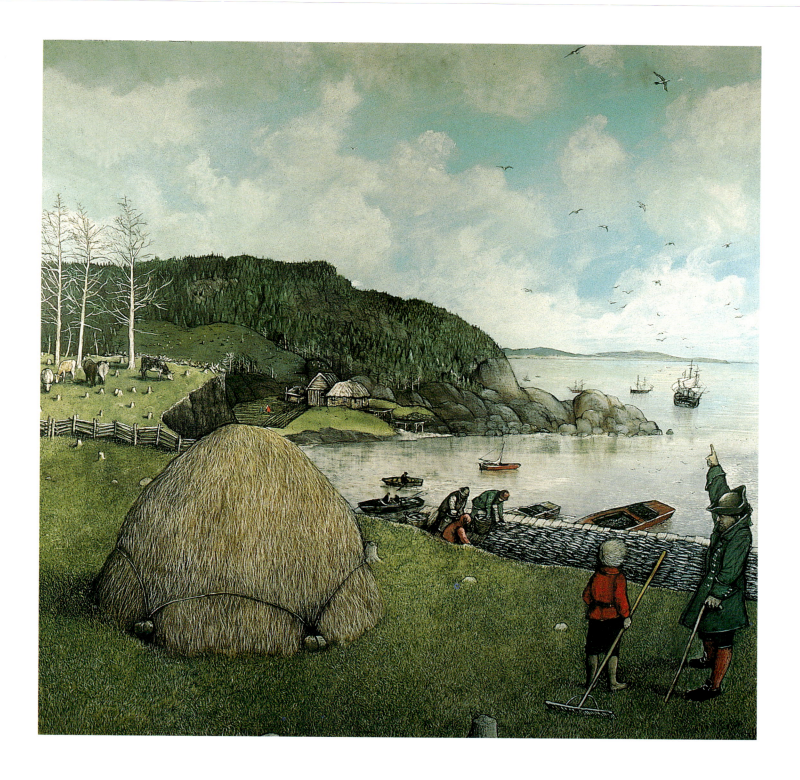

Irish Wake in Montreal 1976
The Irish in Canada Series
Mixed Media
Dimensions: 24 x 24 inches

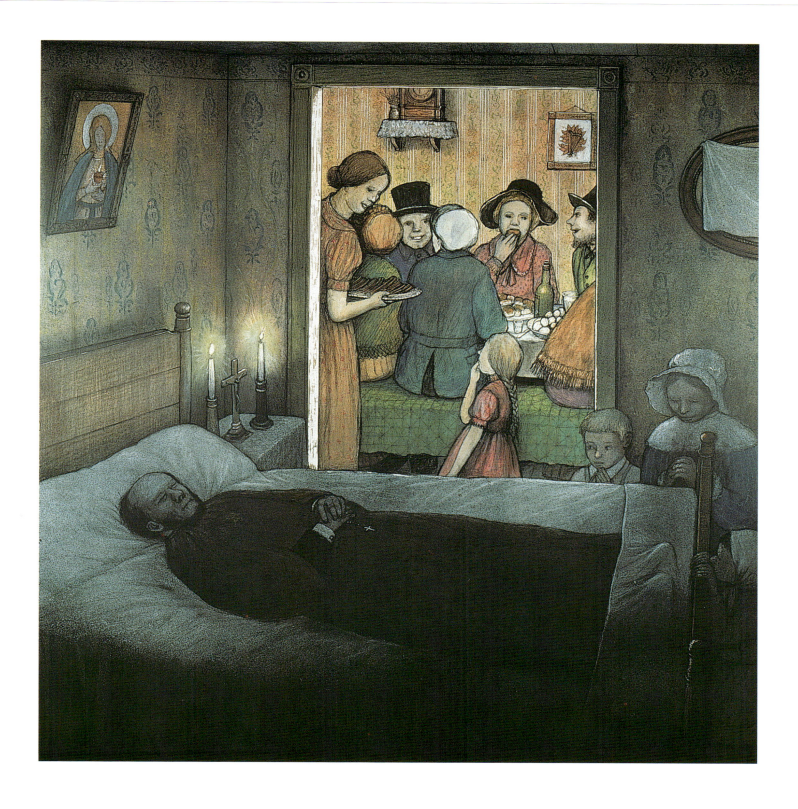

Irish Labour on the CPR above Lake Superior 1976
The Irish in Canada Series
Mixed Media
Dimensions: 24 x 48 inches

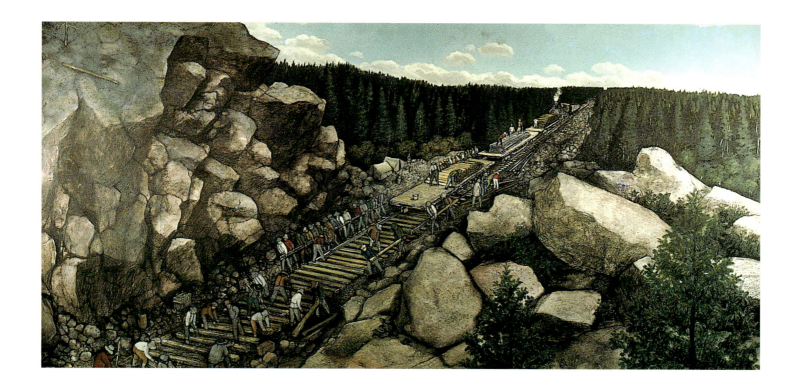

BROTHER KEARNEY AT FORT GOOD HOPE, N.W.T. 1976
The Irish in Canada Series
Mixed Media
Dimensions: 20 x 40 inches

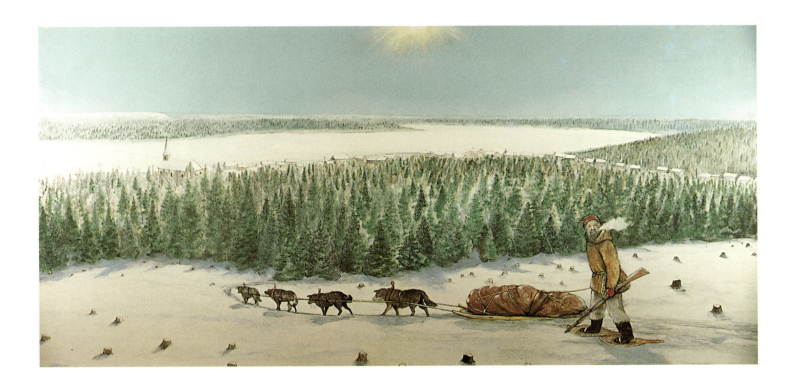

RAILWAY GANG IN B.C. 1977
The Polish Canadians Series
Mixed Media
Dimensions: 28 x 20 inches

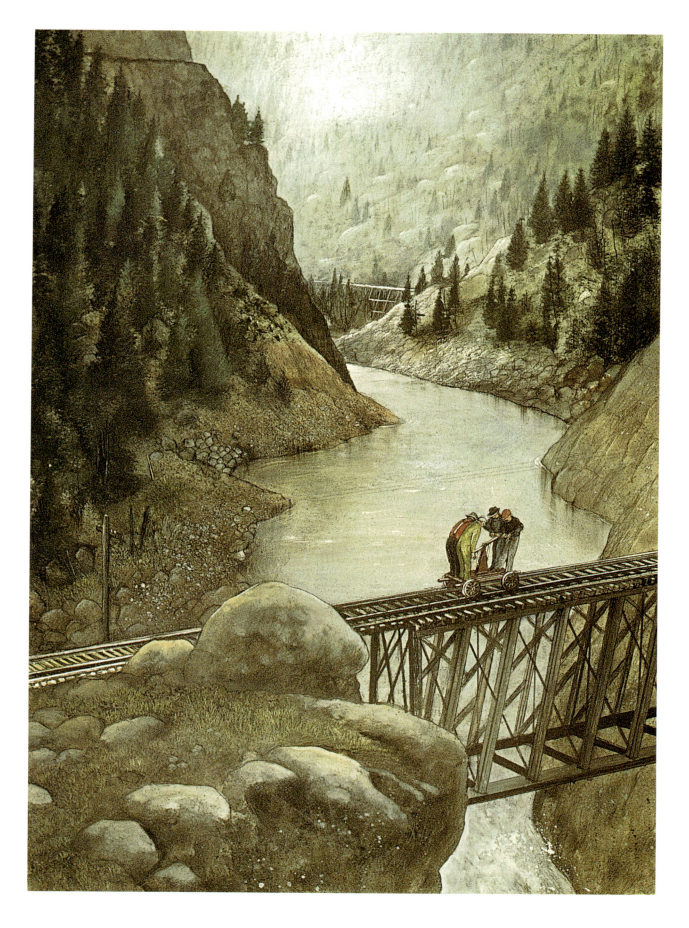

POLISH WEDDING AT KASZUBY 1977
The Polish Canadians Series
Mixed Media
Dimensions: 20 x 28 inches

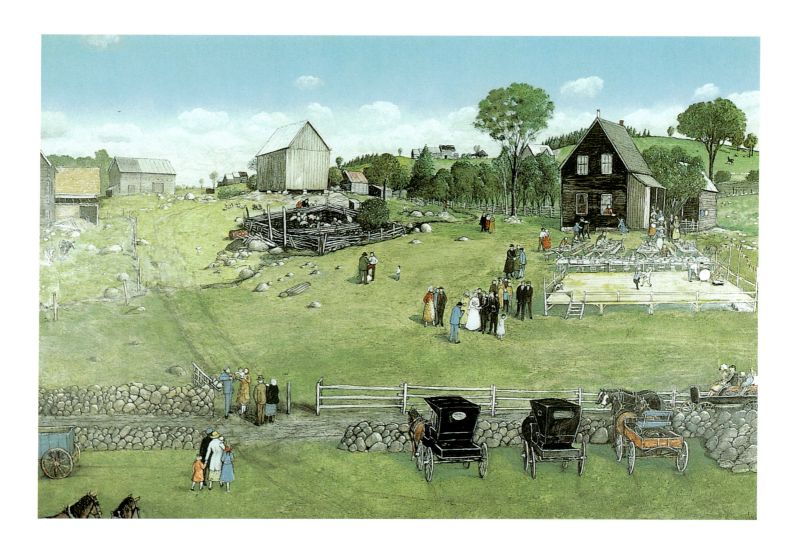

DAMNED POLLACK 1977
The Polish Canadians Series
Mixed Media
Dimensions: 20 x 20 inches

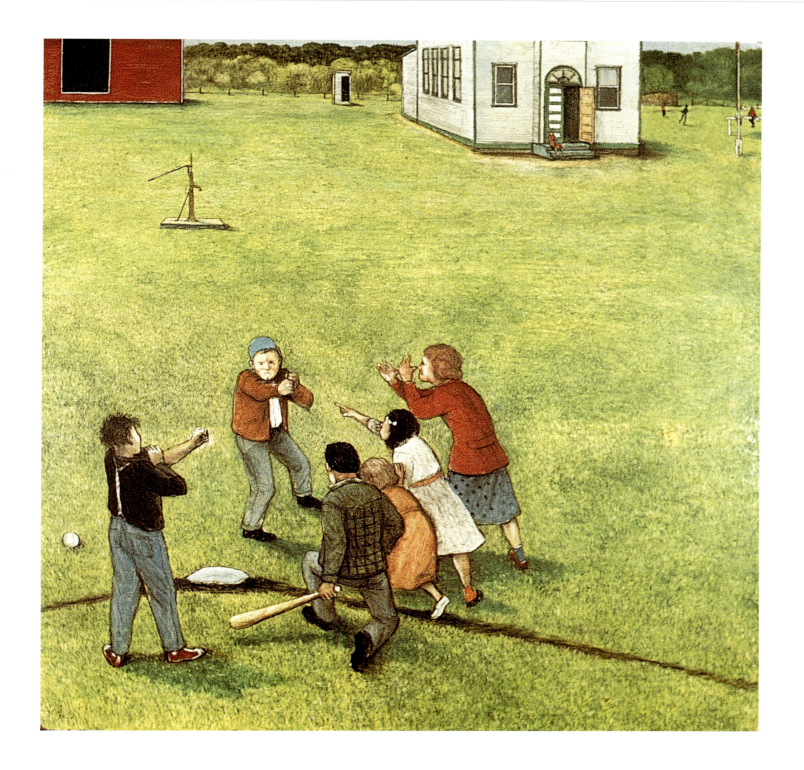

Father O'Connell and the Poles of Sydney 1977
The Polish Canadians Series
Mixed Media
28 x 20 inches

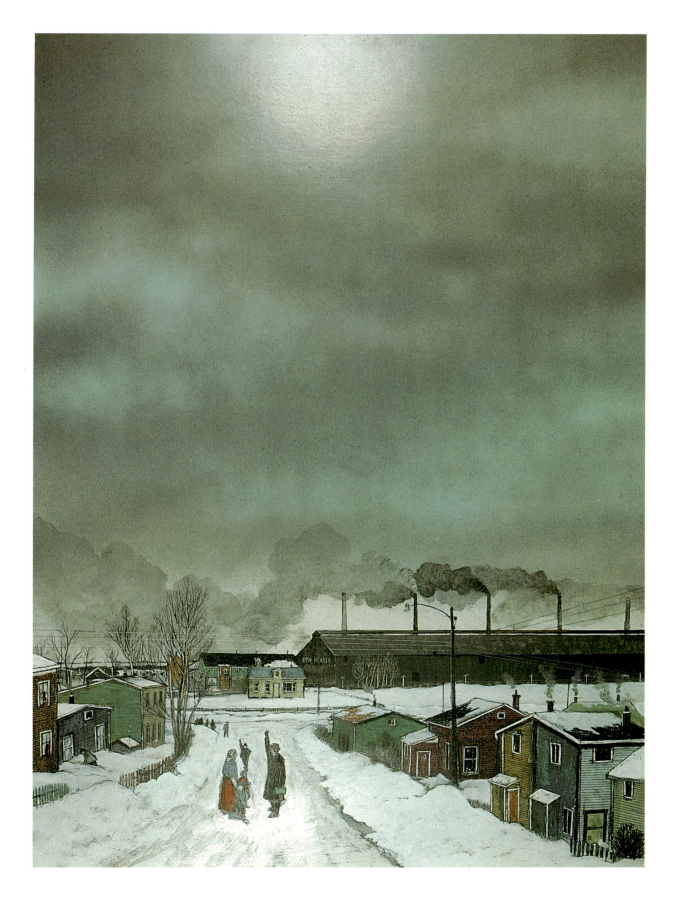

KASZUBY FUNERAL PROCESSION 1977
The Polish Canadians Series
Mixed Media
Dimensions: 18 x 24 inches

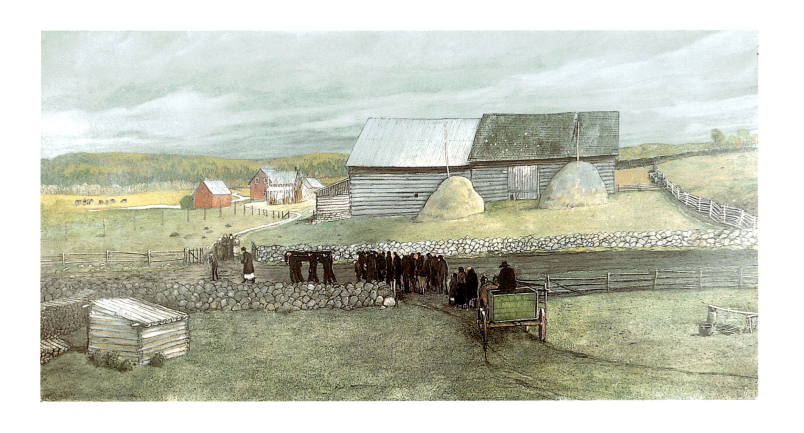

WINTER WINDOWS AND PRAYING BOY 1961
Watercolour
Dimensions: 19 x 23 inches

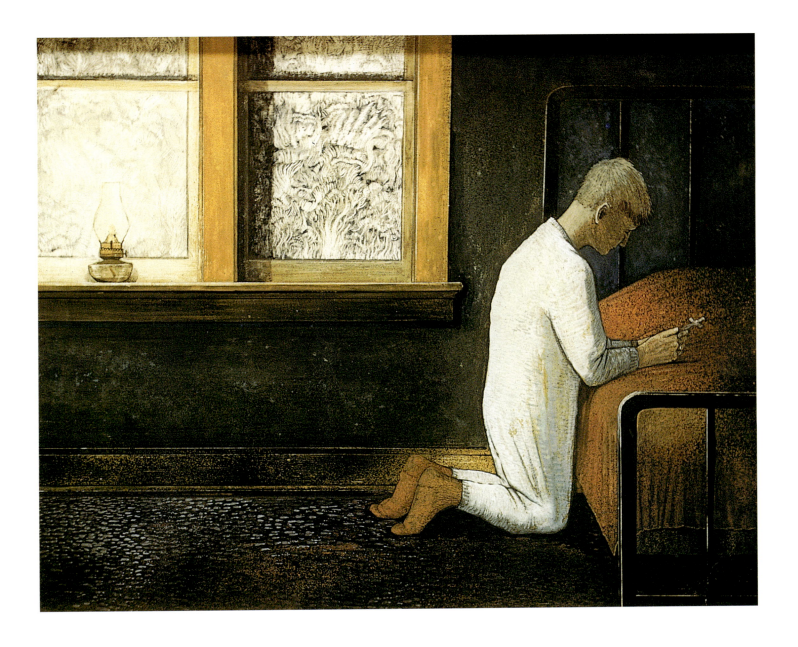

BLESSING THE EASTER PASKA 1966
The Ukrainian Pioneer Woman in Canada Series
Oil
Dimensions: 24 x 17 inches

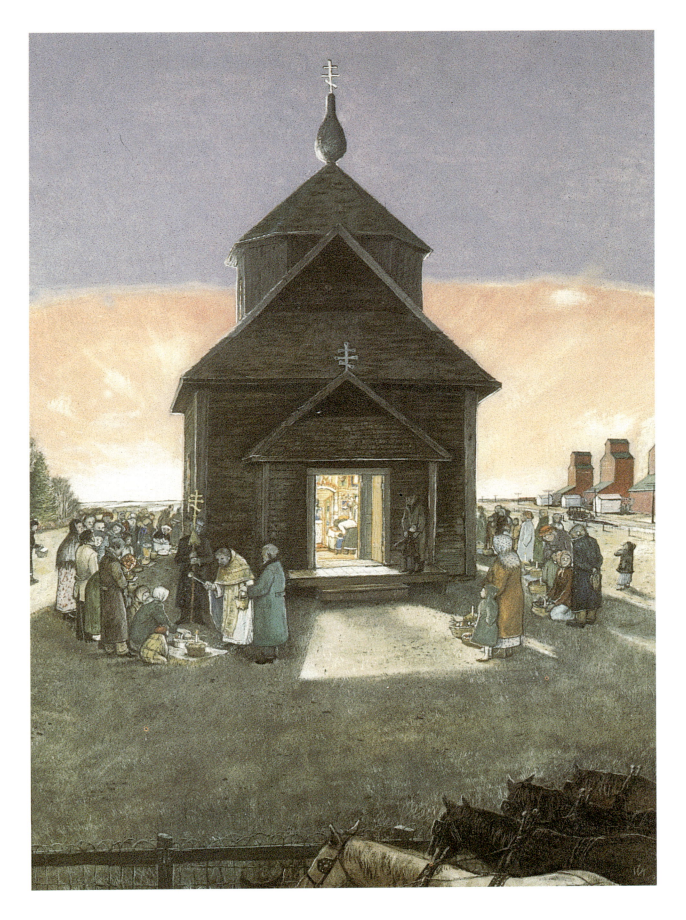

THE DEVIL'S WEDDING 1967
Oil
Dimensions: 53 x 48 inches

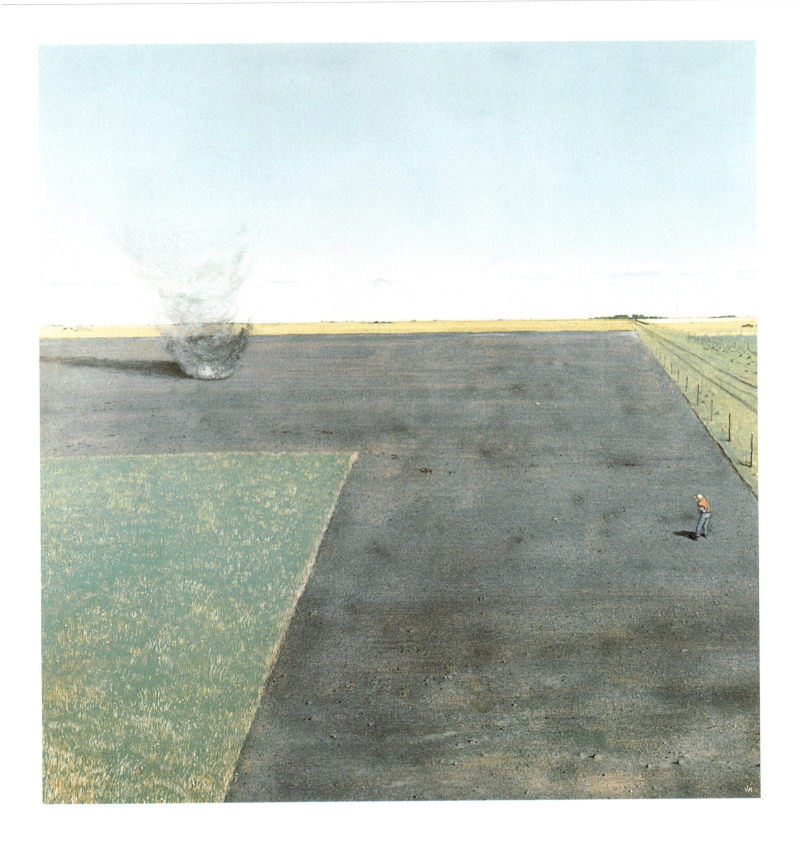

GIRL DANCING IN FRONT OF CHURCH YARD IN MEXICO
Mixed Media

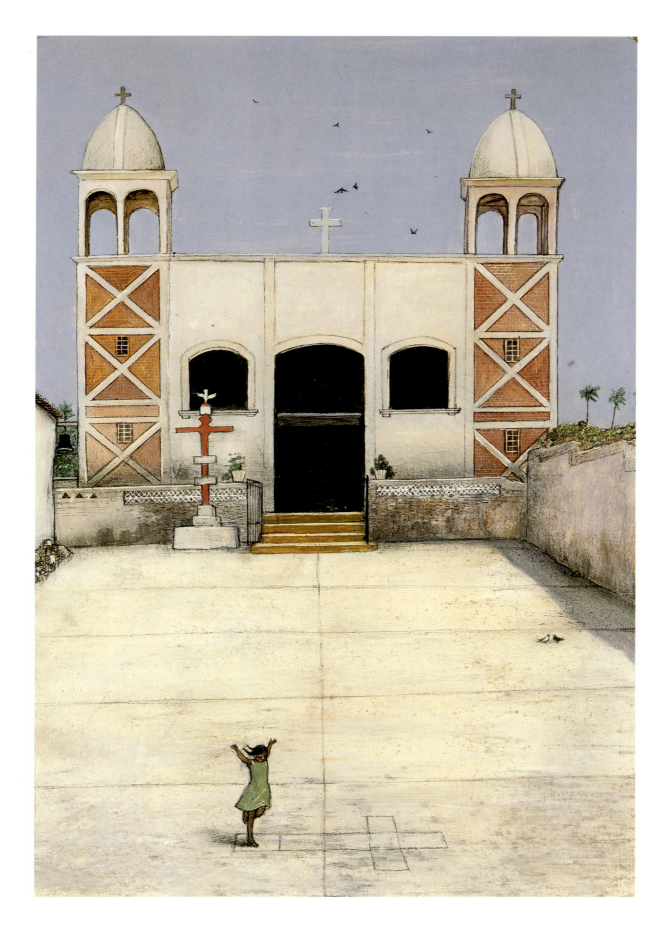

WITH THE EYES OF FAITH 1975
Nativity in Canada Series
Mixed Media
Dimensions: 24 x 24 inches

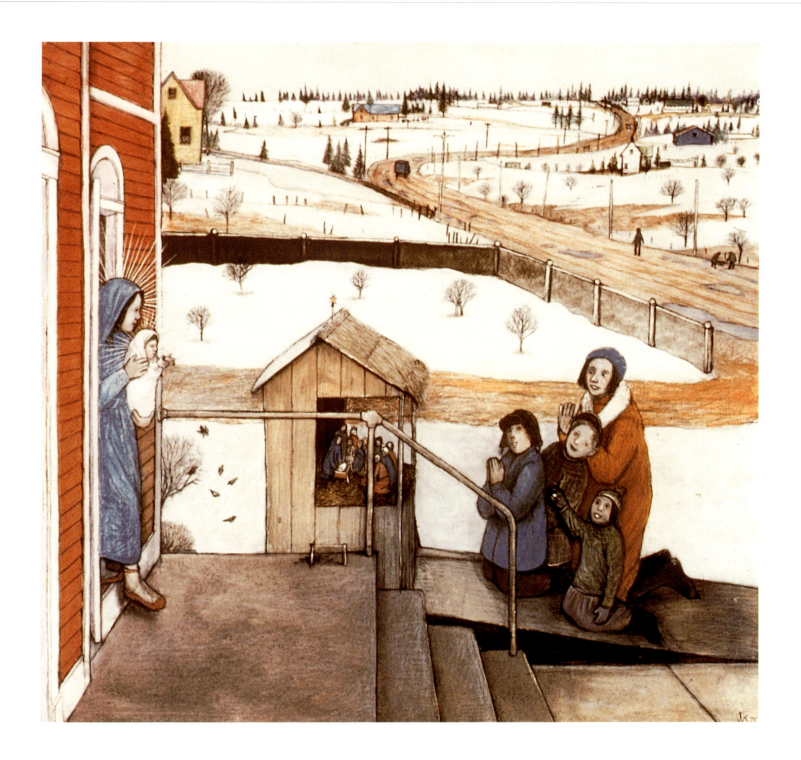

Do Not Trouble Me Now 1975
Nativity in Canada Series
Mixed Media
Dimensions: 24 x 24 inches

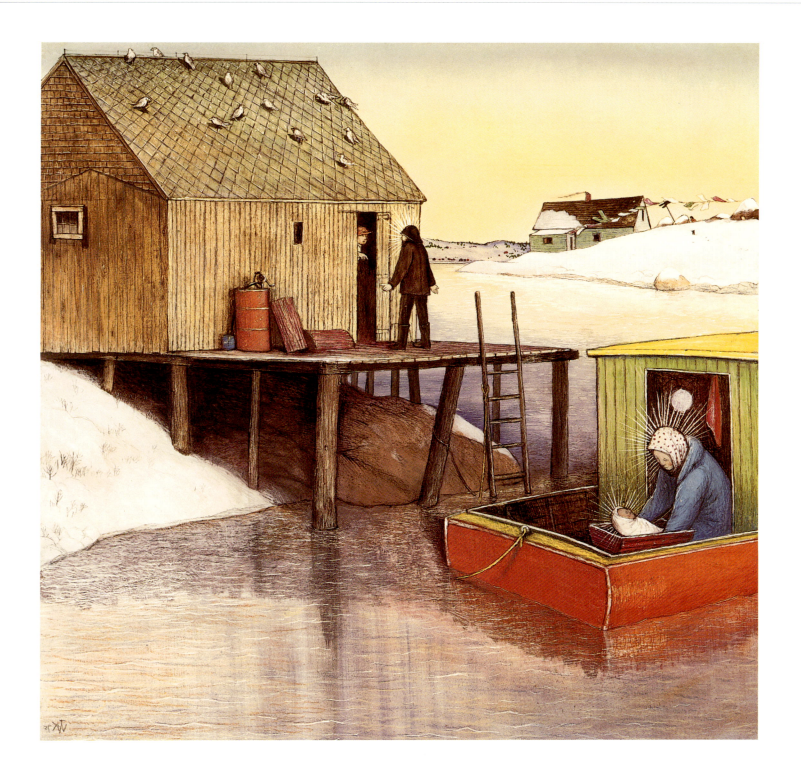

AN ARCTIC NATIVE SINGS 1975
Nativity in Canada Series
Mixed Media
Dimensions: 24 x 24 inches

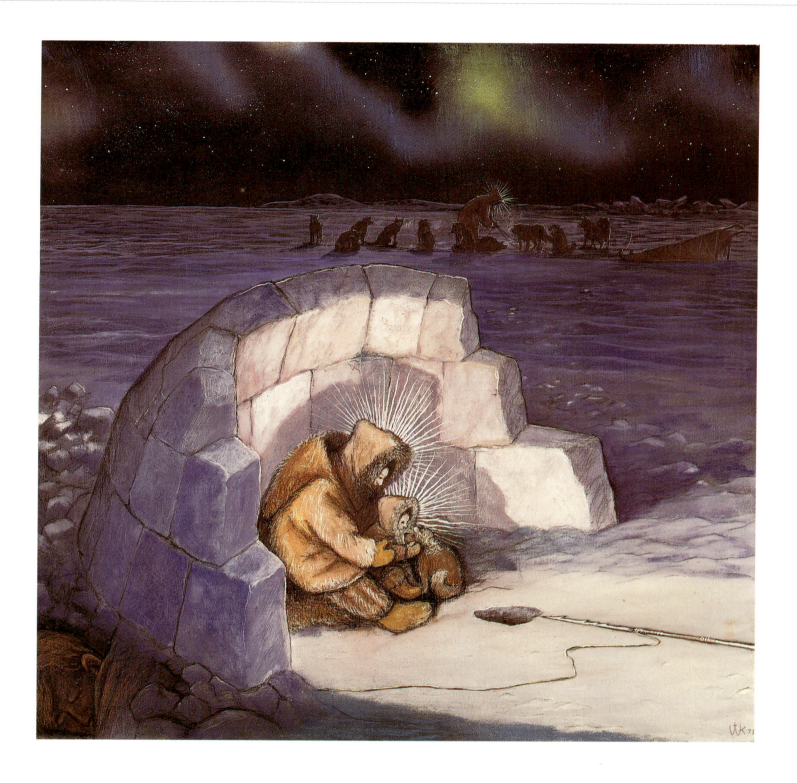

STRANGERS IN BEAUTIFUL BRITISH COLUMBIA 1975
Nativity in Canada Series
Mixed Media
Dimensions: 24 x 24 inches

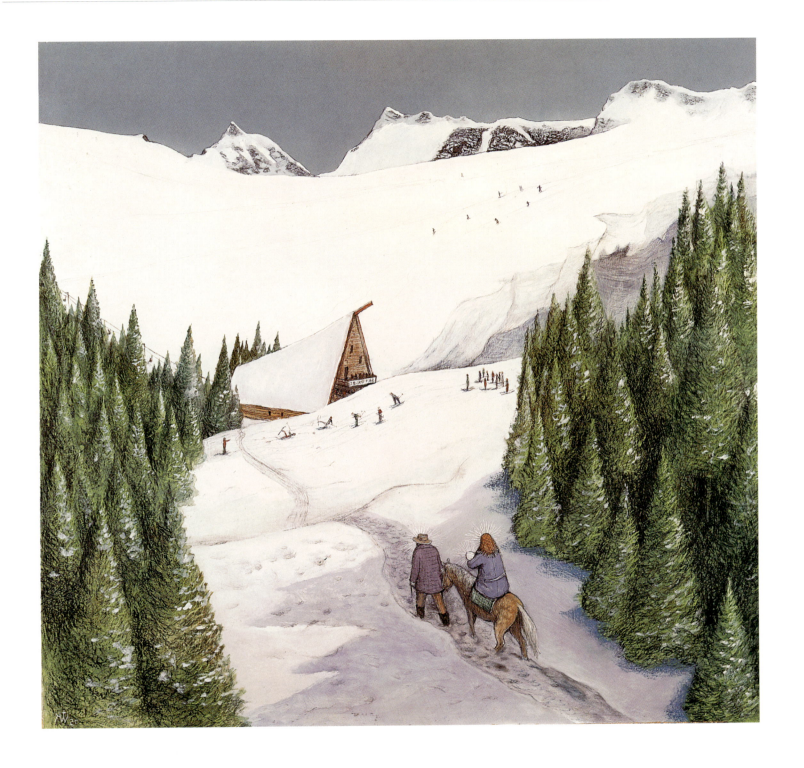

CHRISTMAS MASS AT ST. HILARION 1976
Rural Quebec Today Series
Mixed Media
Dimensions: 28 x 22 inches

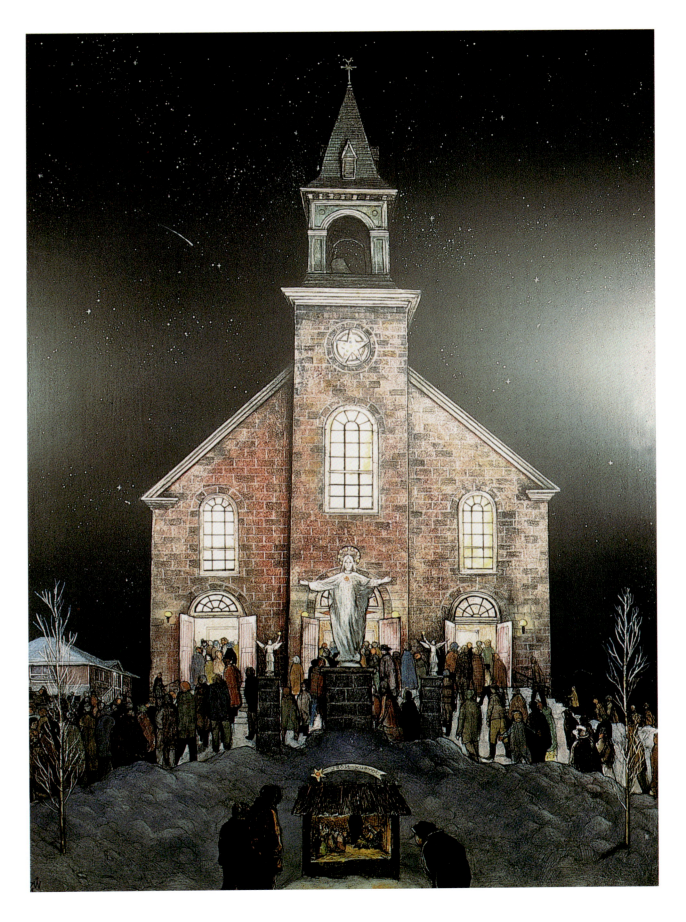

THE MARYSVILLE CEMETARY 1976
Mixed Media
Dimensions: 22 x 24 inches
Collection: The Isaacs Gallery, Toronto

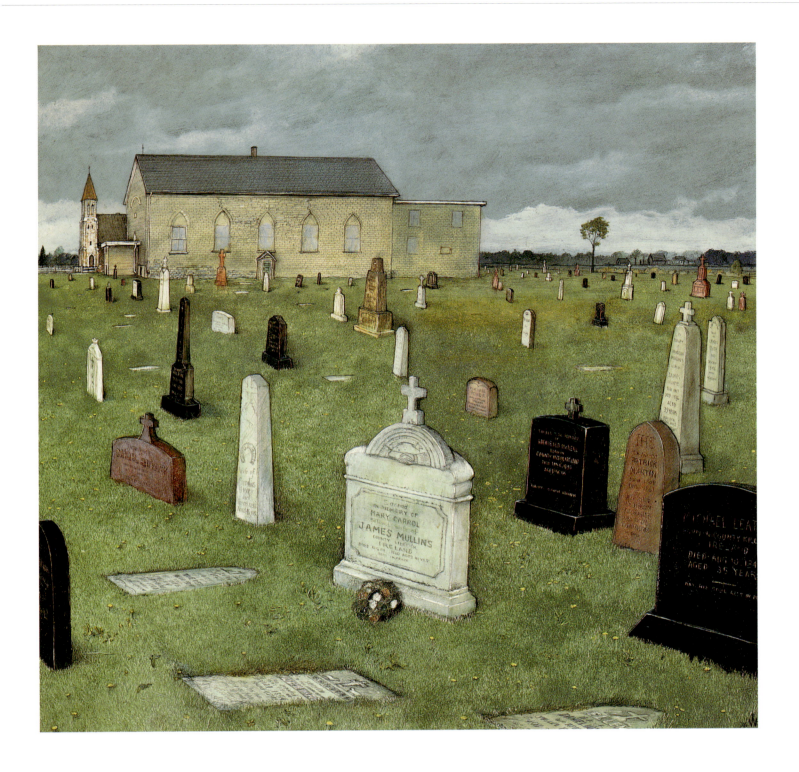

Notes

* This is the text of the William Kurelek Memorial Lecture delivered at the University of Toronto on 4 April 1978. Eleanor Cook, Avrom Isaacs, Martha Black and Lu Taskey helped me in indispensable ways in preparing this lecture. I owe each a special expression of thanks for the generous manner in which they shared their knowledge with me. This lecture was illustrated by a large number of slides of Kurelek's works.

1 Ron Stansitis, "The People's Painter: William Kurelek 1927–1977," *The Golden West* 13, no. 1:22–30.

2 Isaacs Gallery, Toronto, "Foreword to Toronto Show" (1973), ms.

3 Elizabeth Kilbourn, "Dogma and Experience," *Toronto Star*, 18 May 1963.

4 E.H. Gombrich, *Art and Illusion* (Princeton, 1969), p. 86.

5 William Kurelek, *Someone with Me* (Ithaca, N.Y., 1973), p. 206. Toward the end of *Portrait of the Artist*, Stephen Daedalus proclaims that "I will not serve that which I no longer believe, whether it call itself my home, my fatherland, or my church; and I will try to express myself in some mode of life or art as freely as I can and wholly as I can, using for my defense the only arms I allow myself to use—silence, exile, and cunning." James Joyce, *Portrait of the Artist As a Young Man* (London: Travellers' Library Edition, 1951), p. 281.

6 Isaacs Gallery, Diary of Ohio Painting Trip, 1967, ms.

7 *Promin* (English Section), March 1974, p. 14.

8 Kurelek, Someone, p. 523.

9 William Kurelek, *The Passion of Christ According to St. Matthew* (Niagara Falls, Ont.: Niagara Falls Art Gallery and Museum, 1975), p. 12.

10 Isaacs Gallery, Diary of Ohio Painting Trip, 1967, ms.

11 Eli Mandel, *Another Time* (Toronto, 1977), pp. 50–2.

12 *William Kurelek: A Retrospective* (The Edmonton Art Gallery, 1970).

13 William Kurelek, *Kurelek's Canada* (Toronto, 1975), p. 12.

14 Isaacs Gallery, William Kurelek to Av Isaacs, 2 September 1963.

15 W.O. Mitchell, *Who Has Seen the Wind*, illus. By William Kurelek (Toronto, 1976), p. 3.

16 John Newlove, "East from the Mountains," *Moving in Alone* (Toronto, 1965), p. 50.

17 Wallace Stegner, *Wolf Willow* (New York, 1962), p. 7.

18 Fredelle Bruser Maynard, *Raisins and Almonds* (Toronto, 1972), pp. 187–8.

19 Isaacs Gallery, Diary of Sudbury Trip, 15 June 1966, ms.

20 Isaacs Gallery, Diary of an Alberta Trip, 6 February 1966, ms.

21 Kurelek, *Someone*, p. 151.

22 Walter S. Gibson, *Breughel* (New York and Toronto, 1977), p. 151.

23 Isaacs Gallery, "Ukrainian Women Pioneers in Canada," ms.

24 John Marlyn, *Under the Ribs of Death* (Toronto, 1964), p. 216.

25 William Kurelek, *O Toronto* (Toronto, 1973).

26 Kurelek, *Kurelek's Canada*, p. 29.

27 Northrop Frye, *The Bush Garden* (Toronto, 1971), pp. ii–iii.

28 William Kurelek, "Development of Ethnic Consciousness in a Canadian Painter," in W. Isajiw, ed., *Identities: The Impact of Ethnicity on Canadian Society* (Toronto, 1977), pp. 53, 55.

29 Isaacs Gallery, Diary of a Painting Trip to Sudbury, 15 June 1966, ms.

30 Kurelek, *Someone*, p. 333.

31 Francis Thompson, "The Hound of Heaven," *Complete Poetical Works of Francis Thompson* (New York, 1913), p. 88.

32 For example, "Lord that I May See" (1950) and "Behold Man without God" (1955).

33 Gertrude Schiller, *Iconography of Christian Art* (Greenwich, Conn., 1971), 2:ix.

34 Kurelek, *The Passion of Christ*.

35 Isaacs Gallery, William Kurelek, "Errors in Star Weekly Article," ms.

36 Isaacs Gallery, undated scrap of paper.

37 Isaacs Gallery, "Experiments in Didactic Art, May 1963." See a discussion of this question in Ralph E. Shikes, *The Indignant Eye: The Artist as Social Critic* (Boston, 1976).

38 Isaacs Gallery, William Kurelek to Av Isaacs, 1963.

39 Harry Malcolmson, "Art and Morals," *Toronto Telegram*, 12 March 1966.

40 Isaacs Gallery, William Kurelek to Harry Malcolmson, April 1966.

41 Kurelek, *Someone*, p. 516.

42 Kurelek, *O Toronto*, pp. 2, 4.

43 Isaacs Gallery, William Kurelek, "Notes on the Last Days."

44 Isaacs Gallery, "Diary of June 1965."

45 Gombrich, *Art and Illusion*, p. 389.

46 Sinclair Ross, *As for Me and My House* (Toronto, 1970), p. 59.